KANDINSKY

VASILY

KANDINSKY

THOMAS M. MESSER

Thames and Hudson

For Remi

First published in Great Britain in 1997
by Thames and Hudson Ltd, London

Text copyright © 1997 Thomas M. Messer
Illustrations copyright © 1997 Harry N. Abrams, Inc.

British Library Cataloguing-in-Publication Data

A catalogue record for this book is available from the British
Library

ISBN 0–500–08062–3

Printed and bound in Japan

PHOTOGRAPH CREDITS

Photographs of works of art reproduced in this volume
were generally provided by the owners or custodians of the
works, cited in the captions, or supplied from the archives
of the publisher. The following list applies to illustrations
for which an additional acknowledgment is due. Sigrid
Bühring: figure 11. Walter Dräyer, Zurich: plate 2. Copy-
right © The Solomon R. Guggenheim Foundation:
photographs by Myles Aronowitz, plate 32; Carmelo
Guadagno, plate 21; and David Heald, figures 31, 36, 37,
plates 5, 8, 21, 24, 28, 30, 32, 37. Thomas M. Messer: fig-
ure 41. Copyright © The Museum of Modern Art, New
York: plates 7, 25A–25D. Gabriele Münter- und Johannes
Eichner-Stiftung, Munich: figures 7, 10, 11, 13, 19, 21, 22.
Réunion des Musées Nationaux de France: figures 1–3, 5,
23–25, 29, 30, 32, 34, 40, plates 19, 26, 31, 33–36, 39, 40.
Marc Vaux, Paris: figure 4.

FRONTISPIECE: Vasily Kandinsky, 1935
Photograph by Hannes Beckmann

Kandinsky in a concise, accessible fashion, which is my particular aim here, focusing on a manageable selection of works so as to render the artist's complex and varied output somewhat less intimidating.

•

In the course of preparing this book, I incurred many more obligations than I am able to credit, or even remember. While I have based my descriptive texts on sustained contact with the original works, much of the historical information in my introductory essay is derived from secondary sources, which I have tried to absorb and interpret in keeping with my own understanding of Kandinsky's art. (The translations of passages quoted from Kandinsky's writings are mine.) A few of the scholars who contributed most notably to my thinking are mentioned in the text and listed in the Selected Bibliography; but many others, from whom I also derived enrichment, remain unrecorded, since the publisher's format, for the sake of unimpeded readability, dispenses with footnotes. My expression of sincere gratitude, however, is here extended to the following organizations and individuals, who were most helpful to me in the realization of the book: to the Museum of Non-Objective Painting and subsequently the Solomon R. Guggenheim Museum, for having opened my eyes to Kandinsky's epochal achievement; to successive directors and staff members of the Musée National d'Art Moderne, Centre Georges Pompidou, Paris, and the Städtische Galerie im Lenbachhaus, Munich, for allowing me full access to their respective collections and records; to the Robert Gore Rifkind Foundation, Los Angeles, for supporting and facilitating my research under its auspices in 1990; to the late Nina Kandinsky, for many years of friendship, during which she conveyed to me important information relating to her life with the artist; to the Kandinsky Society in Paris and Claude Pompidou, its president, for their care of Kandinsky's legacy and for enabling me to maintain worldwide contact with current issues concerning the artist; to my colleagues in the same Society, and in particular its secretary, Vivian Endicott Barnett, with whom for many years I was privileged to consider research problems related to Kandinsky, and who read the present text in manuscript, providing invaluable comments based on her comprehensive knowledge of the subject; to James Leggio, Senior Editor at Harry N. Abrams, Inc., for his informed and thorough editing of my text; to Uta Hoffmann, also at Abrams, for preparing the book's pictorial contents; and finally, to Abrams' Senior Vice President, Margaret L. Kaplan, for many years of encouragement with the entire project.

T.M.M.

Half a century after his death, Vasily Kandinsky has assumed in our understanding of modern art a position of centrality achieved by only a very few artists of his time. To be sure, the primal explosiveness of Pablo Picasso, the unfailing painterly touch of Georges Braque, or the Mediterranean serenity of Henri Matisse were qualities that remained largely beyond his scope. But Kandinsky brought to bear on his art an instinctive awareness of what constituted the central aesthetic issues of his era. Moreover, he possessed the necessary intellectual scope to articulate that awareness and was able, therefore, to conduct a meaningful dialogue between theoretical reflection and pictorial realization. Kandinsky is popularly seen as the "father" of abstract painting; such a designation is, however, generally valid more for the force, fullness, and consistency with which his painting addressed basic pictorial issues than for any claims to chronological primacy, which are as often made on his behalf as they are difficult to sustain. It was, rather, the richness of his morphological development and the strength of his best work that created his artistic legacy.

Perhaps the most conspicuous feature of Kandinsky's work when considered retrospectively is its segmentation into a number of quite distinct, not to say contradictory, approaches. By comparison with such stylistic variability, the art of Paul Klee, for example, despite its rich internal development, can appear to have been cut from one cloth; Piet Mondrian's progression, once his mature style was reached, was subject only to subtle variation; while the work of Joan Miró retained a certain homogeneity, based on a pervasive mood, throughout his creative life. Unlike the work of more singleminded artists, Kandinsky's mature production falls into at least three clearly discernible major phases, each expressive of a different outlook toward art and life. Yet in contrast to Picasso's marked stylistic periods, which often startle us with the abruptness of their idiomatic changes, each of Kandinsky's positions was arrived at slowly, after an ample measure of transitional development; change was always linked, visually and intellectually, to what had come before. In view of such stylistic transformations, opinions abound concerning the relative merits of each of the main phases. In evaluating them, it should be understood how forcefully the very idea of creative change presented itself to the artist. In Kandinsky's long life, a slow process of artistic maturing unfolded amid drastically changing external conditions and ideological reversals, and all were mirrored in the artist's pictorial output.

We encounter in the initial phase of Kandinsky's development, roughly from 1900 to 1914, a gradual shift from overt representation to the attenuation of observed reality and, at the same time, an enhanced expressiveness. At a given point, abstraction—defined as a mode of painting extending beyond the depiction of recognizable objects—became the key issue, for Kandinsky himself as well as for the viewer. In this first phase, with its ever more intense expressivity, the emerging distinction between a kind of painting that has gradually stripped itself of mimetic vestiges and one that has embraced, from the outset, a non-objective mode, becomes increasingly significant. In Kandinsky's subsequent development, roughly from the early 1920s to the early 1930s, the figurative element was virtually

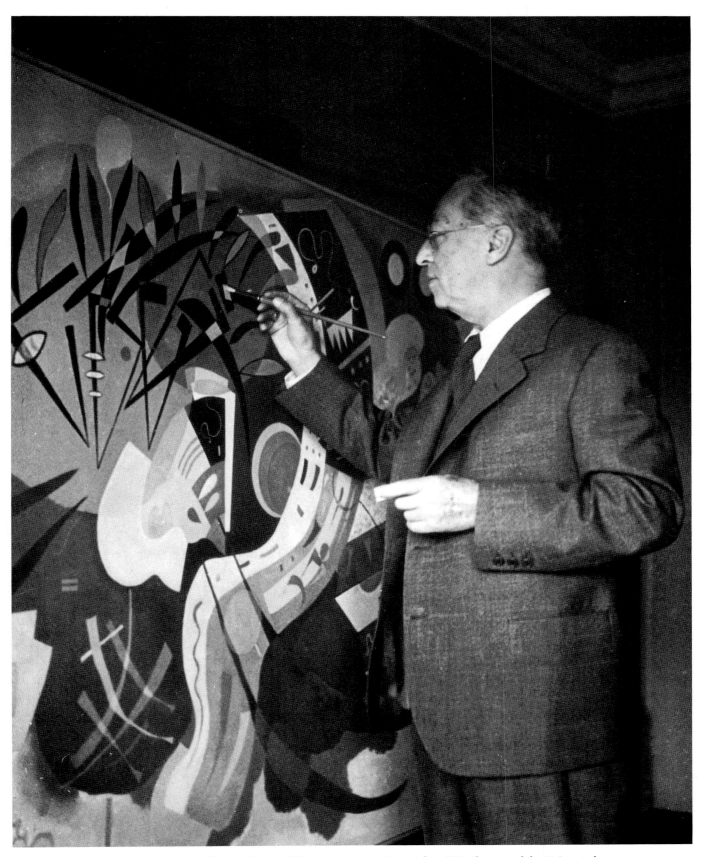

1. Vasily Kandinsky in his studio at Neuilly-sur-Seine, 1938, with *Dominant Curve* (plate 37). Photograph by B. Lipnitzky

excluded, and pictorial content was conveyed through quasi-geometric means. The expressive component of painting was reduced in favor of rational construction. The artist's final major phase, in the last ten years of his life, revealed a painter largely freed from dogmatic prescriptions and capable therefore of responding to fresh stimuli. He found inspiration for a new kind of biomorphic form that allowed him to strike a balance between the objective and the non-objective, the expressive and the rational. In his more than forty years of searching, Kandinsky discovered a series of original and inventive pictorial solutions by going through this process of continuous change and gradual clarification.

FORMATIVE YEARS

When Kandinsky arrived in Munich from his native Moscow in December 1896, to study painting, he was already thirty years old. The decision to become an artist had long been delayed, although in the absence of visible impediments it could have been made much earlier in his life. Young Vasily's father, Vasily Silvestrovich, was a well-to-do tea merchant who lived for many years in Odessa, where Vasily (born December 4, 1866) had spent most of his childhood. Presumably neither of his parents, who divorced in 1871, would have been opposed if their son had expressed a wish to be a painter. But perhaps Vasily was awed by the very thought and hesitant to make such a commitment, notwithstanding the early signs of interest in art and the aptitude as a draftsman that had led his family to arrange for drawing lessons. In his autobiographical essay called *Reminiscences* (first published in 1913 under the German title *Rückblicke*), Kandinsky remembered an unusual sensitivity to stimuli of color when, as a child in Odessa, paint boxes, watercolors, and brushes were provided by his aunt, Elizaveta Tikheeva, who was largely in charge of the boy's upbringing. But evidently such indications were not compelling enough and art, like his learning to play the cello, was at first pursued only as an amateur activity. After attending high school in Odessa, Kandinsky pursued his studies at the University of Moscow in law and economics. The fulfillment of his academic requirements in 1892, when he was in his mid-twenties, led first to a university assistantship there and shortly afterward to the offer of a teaching professorship at the University of Dorpat in the Baltics, which he declined. With his marriage to Ania Shemiakina, a distant cousin, everything seemed to point to a well-ordered bourgeois exis-

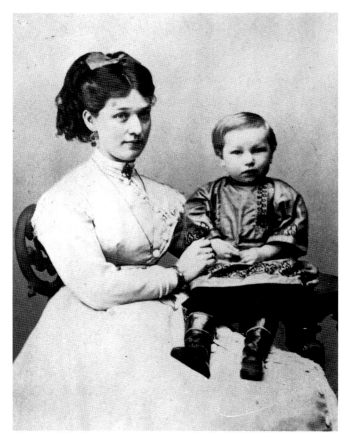

2. Kandinsky and his mother, Lydia Kandinskaia, Moscow, c. 1869

tence. But underneath this calm and conventional surface a slow fire was burning. With seeming suddenness, the young academic abandoned his home and his profession, with its auspicious teaching prospects, and took himself to Munich, the Bavarian capital, which was for many Russians an alternative to Paris for the study of art.

Kandinsky's acute mind and high intellectuality, his diverse interests and his aptitudes for many tasks, as well as his prudence and caution, even perhaps a certain timidity, all conspired to delay the crucial decision almost beyond the point at which it could be acted upon. But act Kandinsky did, as he embraced in 1896 the life of a painter.

•

Kandinsky had not come to his vocation without a sense of mission. Still, he could hardly have foreseen at the time of his arrival in Munich that about a decade and a half later, he would have emerged, in the city he had chosen for his studies, as the leader of a substantial avant-garde, admired by younger friends and followers, yet vilified by some other artists, by art historians and

critics, and by the general public. Neither Kandinsky nor anyone else could have imagined that in a relatively few years he would preside over radically progressive artists' organizations or that he would articulate the meaning of abstract art in one of the most influential treatises on the subject. It was equally unforeseeable that he would be centrally involved in mounting an exhibition program that would become almost legendary, and in editing an accompanying publication that would assume a lasting place in the documents of modern art. Least of all could it be predicted that, as a painter, Kandinsky would spearhead a movement with profound implications for the history of art.

But all this was still far away. What the aspiring painter did know by 1896 was that he wished to dedicate his life to art and that in order to do so, he needed to be instructed in the underlying craft. That was what prompted him to enroll in art school and to avail himself, in the company of much younger fellow students, of the instruction offered in Munich.

Art school, liberally supplemented by independent study, required another few years of rather basic training. When, around the turn of the century, Kandinsky began to function as a painter and printmaker, and subsequently as a teacher in his own right, he was already in his mid-thirties, a circumstance not without relevance

to the shaping of his developing lifework. The urgent need, though he may not have realized at the time, was to find some kind of balance between his still rather elementary level of artistry and his already sophisticated comprehension of aesthetic and philosophical principles. Kandinsky the thinker and Kandinsky the painter, perhaps unevenly endowed and propelled by different timetables, already struck contemporaries as to some extent distinct entities. Thus, the artist's authority as a teacher at the Phalanx school, created in the winter of 1901–2 as an adjunct to the exhibition society of the same name, undoubtedly derived as much from his intellectual as from his creative accomplishments.

Kandinsky's wide-ranging speculative propensities went back to his Moscow youth. In his *Reminiscences,* the artist tells us how, during an ethnographic field trip to the Vologda region of Russia in 1889, he had found himself in a peasant dwelling's interior so colorful and intense that he could imagine himself to be within a painting. It was an experience he never forgot and one that became important to his subsequent ideas about pictorial space. He also reports the effect on him of tonal contrasts in Rembrandt's paintings when, at the age of twenty-three, he had first seen the Dutch master's work at the Hermitage Museum in Saint Petersburg. Even then, he had already begun to understand the

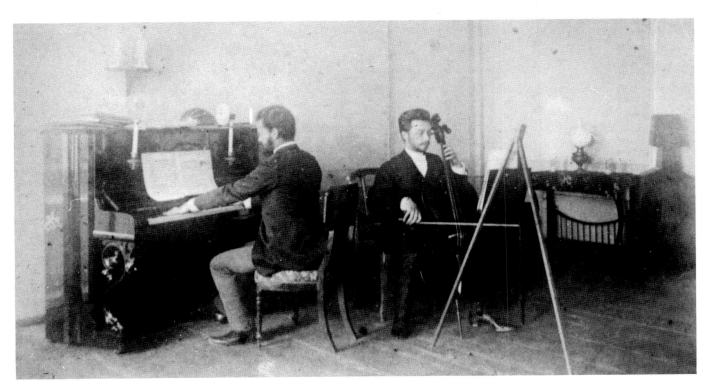

3. Kandinsky playing the cello, c. 1886

need for a gradual education of the eye in its search for inner meaning. In 1896, the year of his departure from Moscow, he saw a painting of a haystack by Claude Monet in which color seemed so powerfully autonomous as to temporarily displace the depicted subject, an experience with far-reaching implications for Kandinsky's own work. Concurrently, there were musical revelations in the young artist's life, such as a performance of Richard Wagner's opera *Lohengrin,* that no doubt prepared the way for his later insights into the ultimate unity of the arts.

Such episodes could not help but affect Kandinsky's early pictorial development. Though evidence is scarce, there is little doubt that Kandinsky drew prior to his arrival in Munich. In *Reminiscences,* he refers to his student days and to copies he made, now lost, of a painting of Christ by V. D. Polenov, presently in the State Tretiakov Gallery, Moscow. And even without this specific indication, it stands to reason that his commitment to art as a career would not have come about without some testing of his capacities and without some direct contact with the profession. Yet next to nothing has been found so far to provide insight into the artist's preparatory phase, nothing that would shed light upon the first, undoubtedly derivative beginnings that we can assume preceded his going to Munich.

As for the art-school years, they are represented only putatively by an Odessa harbor scene now in the Tretiakov Gallery. If this uncertain work can be established as being from Kandinsky's hand, it would probably have had to be completed in the late 1890s. Nothing, however, has surfaced by which to judge why his fellow students at Anton Ažbè's private art school, which he attended during 1896, mockingly called Kandinsky a "colorist"; nor is there anything specific to help us visualize the drawings first presented to the Munich painter and teacher Franz von Stuck, who accepted Kandinsky into his drawing class in 1898, although he had failed the entrance exam to the same academy a year earlier. It is only around the year 1900 that we have the first meaningful testimony of Kandinsky's independent work. (There are drawings and sketchbooks that date from before 1900, as well as a poster from late 1896 or early 1897, but no paintings that can be proven to have been done in the 1890s.)

At first, Kandinsky functioned largely as a landscape painter, coming to terms with the visible world around him. At the time, there was perhaps no other way for him. He may already have had intimations of a larger potential for painting than the careful retracing of nature. But even so, the storing of observed forms in his memory would be essential to his subsequent capacity for abstracting them, and to the very thought process that led to such a possibility. For many artists, questions about the purpose of making art become answerable only in the act of realization, and Kandinsky, perhaps sensing this, pursued his painting with passionate zeal.

In the first years of the new century, even as his essays and his reviews of art exhibitions began to appear in German and Russian periodicals, Kandinsky was still working to orient himself more securely within the realm of art making. A waterfall is among his earliest painted subjects (*Kochel—Waterfall I,* dated variously between 1900 and 1902). It is repeated a year or two later, a bit clumsily, in strong, contrasting colors and a rough texture (*Kochel—Waterfall II*). In 1901, Kandinsky recorded the changing seasons. First there were images of the snow-covered streets and house fronts of Schwabing, where he lived, which was then still a suburb of Munich (see figure 4). Renditions of lush summer vegetation in the surrounding countryside follow later in the year. Then, the darkened leaves and black ponds of a dying fall are observed during one of his periodic visits to his relatives' estate at Achtyrka, outside Moscow (figure 5).

In Kandinsky's manner of working, the act of viewing and the act of painting remained distinct—the former conducted in front of the subject matter, the latter done from memory in the comfort of the studio. The cardboard or canvas supports he painted on were small, only infrequently exceeding dimensions of thirty-three centimeters in height or width. Judging from available photographs of the city and country sites depicted, most paintings of the period are quite literal. The dense surfaces, with a preponderance of nature's green and brown colors, are descriptively prosaic, somewhat in the manner of nineteenth-century *plein-air* painting, the outdoor mode that immediately preceded Impressionism in France. Gradually, some of these works assume a dreamy quality in which longer strokes and smoother surfaces take the place of the choppy rhythms that characterized his earlier pictures. The work of Edvard Munch, the great Norwegian painter, comes to mind at times when Kandinsky resorts to summary treatment of trees or the reflections of buildings on watery surfaces.

Year after year the artist painted cities and towns, their streets, houses, and gardens, as well as the countryside of fields, woods, bodies of water, and mountains. Mostly these stand as isolated motifs, but occasionally they reappear in closely related versions. In paintings

4. *Schwabing—Winter*. 1901. Oil on canvas, 9½ × 13″(24 × 33 cm). Musée National d'Art Moderne, Centre Georges Pompidou, Paris. Bequest of Nina Kandinsky

5. *Achtyrka—Park*. 1901. Oil on cardboard, 9½ × 13″(24 × 33 cm). Musée National d'Art Moderne, Centre Georges Pompidou, Paris. Bequest of Nina Kandinsky

6. *Kallmünz—Gabriele Münter Painting I.* 1903. Oil on canvas-board, 9¼ × 12⅞″ (23.7 × 32.7 cm). Städtische Galerie im Lenbachhaus, Munich

7. Gabriele Münter in Dresden, 1905. Photograph by Vasily Kandinsky

such as *Study for "The Sluice"* of 1901 (plate 1), which was followed by a larger version, or again in the Munch-like *Evening* of 1902, we encounter canvases in larger dimensions based on preparatory sketches and studies.

The human figure enters Kandinsky's landscape paintings haltingly, during 1902, to remain in evidence thereafter. There are group images of pedestrians but also single figures of standing or seated women, some painted in the Bavarian village of Kochel and identified as Ania, the artist's first wife, or Gabriele Münter, one of his Phalanx students, with whom Kandinsky had fall-

en in love in that year (see figures 6, 7). Riders on horseback first make their appearance in a casually descriptive way, but as early as the 1903 painting *The Blue Rider* (plate 2) the subject assumes Romantic connotations through the rendering of a mysterious, solitary horseman swiftly traversing an open field.

Gradually, Kandinsky's pictorial spaces became more defined. Nostalgic sentiments and an interest in historical imagery, evoked through references to mounted processions in old Russia, are evident in larger horizontal canvases (see figure 8). Paintings like *In the Forest* of 1904 (figure 9), where a lance-bearing horseman relates to one of the artist's favorite subjects, Saint George, convey a sense of fairytale. Isolated instances of still life painting in the same year, and even a formal portrait of Gabriele Münter in 1905, are indications of Kandinsky's broadening interest and developing capacities. It is during this phase only that works of conspicuous distinction begin to punctuate the patient learning process that Kandinsky had initiated in the early Munich landscapes. Paintings of Tunis and Carthage, for example, completed in 1905 during an African journey, can make such a claim, with the new awareness of light that this continent has bestowed upon European painters from Eugène Delacroix to Jean Dubuffet. The numerous seascape paintings in and around Rapallo and Sestri in Italy, or the beach scenes done two years earlier in Holland, assume a new authority as well, through larger and more defined volumes, subtle coloration, and a probing of the picture's space that was lacking in his first efforts. And *Riding Couple* of 1907 (plate 4) must surely rate among the most accomplished of Kandinsky's early achievements. It may, indeed, be said to close the book on a phase that, as a whole, remained introductory. For what Kandinsky produced during the years of initial commitment to his chosen profession, while of course not uninteresting in the retrospective evaluation of his subsequent lifework, would hardly have secured him a place in a general history of art had it remained isolated from subsequent achievements. The production of the years from 1900 to 1908 is nevertheless impressive for its sheer quantity. More than two hundred oils and at least that many tempera paintings, gouaches, and watercolors provide ample testimony to the artist's urgent need to grasp the forms of nature, even as he would dream of an art form that transcended them.

•

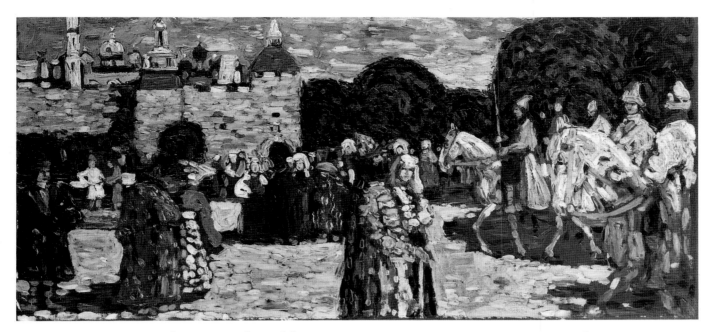

8. *Sunday (Old Russia)*. 1904. Oil on canvas, 17¾ × 37⅜″ (45 × 95 cm). Museum Boymans–van Beuningen, Rotterdam

Between 1906 and 1908, years when his work was reaching a higher level of accomplishment, Kandinsky was almost constantly on the move. The travel habit had already been inculcated in his childhood, when the barely three-year-old boy was taken to Italy by his parents. It continued through his student days in Moscow with travels in Russia as well as beyond its borders. His first two trips to Paris probably fell within that period. During the Munich years, he kept in touch with family, friends, and colleagues in Moscow as well as in Odessa through frequent visits to Russia.

After Kandinsky's involvement with Gabriele Münter, travel became a way of life. Besides exploring the immediate surroundings in Schwabing, the English Garden, or the parks around the Rococo castle of Nymphenburg, Kandinsky and his students would make excursions to the nearby lakes at Starnberg and Kochel and travel to the village of Kallmünz. He took extended trips through Germany and Austria, as well as Holland, Italy, Tunis, and Switzerland. In addition to a prolonged stay in France during 1906–7, frequent visits to Paris and Berlin, with participation in seasonal exhibitions, were also arranged. And Kandinsky traveled eastward, through Hungary and Poland, on his periodic visits to Russia. Some of this breathless travel is recorded in oil with brush and palette knife on cardboard or canvasboard, occasionally yielding an outstanding work like *Holland—Beach Chairs* of 1904 (plate 3). Münter, who frequently accompanied Kandinsky during such travel,

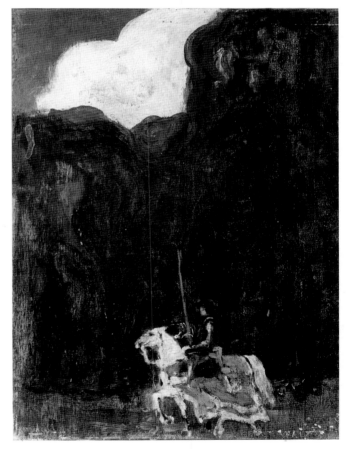

9. *In the Forest*. 1904. Mixed mediums on wood, 10¼ × 7¾″ (26 × 19.8 cm). Städtische Galerie im Lenbachhaus, Munich

15

had committed herself to him in 1903, a year and a half after they had met. Kandinsky and his wife, Ania, who continued to live in Munich, separated in 1904, and an amicable divorce was eventually arranged in 1911. Münter remained Kandinsky's companion for a total of thirteen years, but the foreseen marriage never took place, and the two parted ways in 1916.

Besides providing occasion for work or rest, Kandinsky's travels served the purpose of informing him about creative issues both East and West. The question of what he saw of the art of his time has preoccupied art historians and others concerned with his stylistic derivation. These matters are not easily resolved. All artists do, of course, come from somewhere, and even the most gifted must assimilate the art around them before they become capable of true originality. Kandinsky's very late start as a painter crowded that process of absorption. In the Munich years, he was under pressure to see as much as he could, to absorb quickly and to arrive at a formal language suited to his needs. Yet such pressures ran counter to his cautious and contemplative temperament, which would not incorporate what had not yet become an organic part of his thought.

What was there, in any case, for Kandinsky to take from other sources upon his emergence from art school, and what was there to be absorbed in his subsequent travels? His early work moved, idiomatically, between conventional *plein-air* painting and late Impressionism, both well suited to the landscape painter's mimetic objectives, to the rendition of the world of common experience. The more avant-garde Art Nouveau style, or Jugendstil as it was called in German, provided models for the illustrations that Kandinsky pursued, primarily in his woodcuts, from 1903 on. It is arguable that insights gained from the handling of one medium may impress themselves upon another, and some features from Kandinsky's prints are recognizable in his paintings. But theories that would trace his formal origins directly to Art Nouveau remain contested and, to many, unconvincing.

Among other contemporary tendencies, Neo-Impressionism, which attempted to systematize the preceding, intuitive Impressionist mode, as well as French Fauvism and the Expressionism of the German Brücke artists—both in varying degrees emotive styles relying on color as the primary means of expression—have all been discussed in the Kandinsky literature as possible sources for his developing, autonomous art. Among such alternatives, Kandinsky's interest in Neo-Impressionism, or Divisionism as he preferred to call it, is both

documented and plausible. Georges Seurat's and Paul Signac's system of applying paint in dots or points represents, after all, an effort to calculate the specific effects of color on the viewer's perception, and in this sense it would have direct bearing upon Kandinsky's theoretical investigations. His occasional recourse to broken brushstrokes and mosaic patterns also lends credibility to a certain debt to Neo-Impressionism, even though the visual similarities are limited to only a few examples. Much closer in appearance to Kandinsky's work after 1908 is Fauvism as practiced by Henri Matisse, whose summarily colored, more loosely brushed painting, early in the century, supplanted the preceding fragmented, "pointillist" styles. Kandinsky undoubtedly saw Fauve paintings in 1906–7 during his yearlong stay in Paris, which may have caused him to reconsider the decorative and expressive functions of color in his own work. But the degree of Kandinsky's dependence on Fauvism is uncertain. The Expressionism of the Brücke painters, whose own position with respect to Fauvism remains undefined, is in the last analysis related to Kandinsky's explorations as well. The Russian, however, never acknowledged a kinship with an art so emotive and so German, nor did he establish sympathetic personal contacts with its proponents. Perhaps it should be insisted again that assertions of "influence" tend to be exaggerated when they imply a direct transference. Art historians plead for more time to investigate the relationships just mentioned as well as those of subsequent phases in Kandinsky's development, such as his contacts with the Russian avant-garde during and after the Revolutionary period, or with Surrealism during his Parisian exile before and during World War II. Although more information may become available, it seems doubtful that the problematic nature of such relationships will be resolved, since even the artist himself may not have been fully aware of the complex dynamics regulating the flow from one sensibility to another.

TOWARD ABSTRACTION

In 1906–7, there was, for the first time, a marked decrease in Kandinsky's production. The reasons for this are difficult to know, but it is generally assumed that pressures related to his search for a creative identity may have weighed heavily. Emerging problems in his relationship with Münter could also have been a contributing factor. But whatever the causes, the crisis was surmounted by the summer of 1908, when Kandinsky

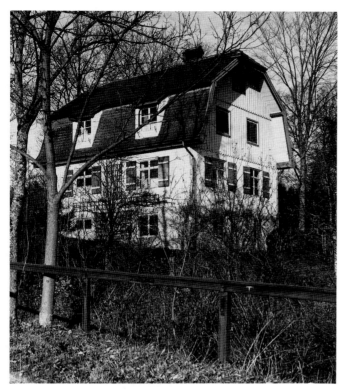

10. Münter House (also called the "Russenvilla"), Murnau, before its renovation. Photograph by Gabriele Münter

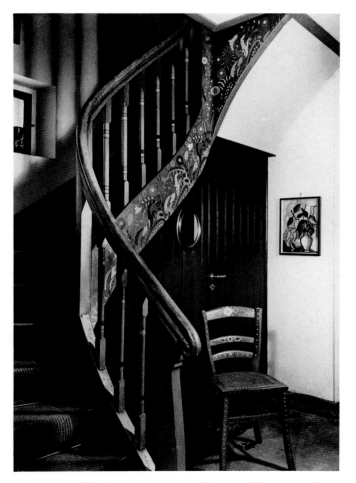

11. Staircase of the Münter House, with painted decorations by Kandinsky, c. 1911. Photograph by Sigrid Bühring, 1930

and Münter first came to stay in the quiet Bavarian village of Murnau in the foothills of the Alps, some seventy kilometers south of Munich. The hectic travel schedule came to an end as Kandinsky settled down to purposeful work. The two of them stayed at first at an inn, in 1908. They returned to Murnau the following summer, and from then on Kandinsky and Münter lived in the house that she would purchase at the end of that summer (see figures 10, 11). It is in paintings such as *The Blue Mountain* (plate 5), *Picture with an Archer* (plate 7), and above all *Sketch for "Composition II"* (plate 8), that the changes from the painter's earlier phase become manifest.

When Kandinsky resumed work at full speed (completing over seventy paintings in 1908, about as many as in the two previous years combined), he began to paint landscapes, executed in oil with brush, either on cardboard or canvas. But what is more important, Kandinsky's paintings suddenly looked quite different, reflecting, no doubt, the clarification of his analytical thought. Advances may surely be attributed to years of active experimentation as a practicing painter and to regular contact with the art scene.

Yet for a time, such signs of maturing were more evident in the painter's formal means than in his themes. Landscape, now primarily relating to Murnau and its surroundings, continued to serve as subject matter. As in earlier years, paintings in 1908 still recite their winding roads, house fronts, and garden patches, their trees in green nature, and an occasional waterfront with boats. A frequent motif is the church in Murnau, situated prominently on a hill under blue skies with scattered clouds (for a later treatment of the subject, see figure 14). The following year, such scenes alternate with urban views as the artist moves between his residences in Murnau and Munich. City crowds and buildings, notably the Ludwigskirche, are included among the exterior views, while the paintings of the bedroom and dining room in Kandinsky's apartment on the Ainmillerstrasse provide glimpses into his private surroundings (see figures 12, 13). Figures still remain exceptions in the artist's widening repertoire.

In a number of ways, the Murnau paintings make plain Kandinsky's new level of achievement. They are, on the average, somewhat larger than those previously completed. They are also more firmly composed, particularly when based on preparatory studies, whose number has risen. The use of less impasto and longer brushstrokes provides smoother surfaces. The clumsiness of many early works is no longer in evidence as col-

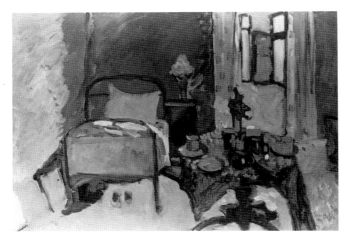

12. *Bedroom in Ainmillerstrasse.* 1909. Oil on cardboard, 19⅛ × 27⅜″ (48.5 × 69.5 cm). Städtische Galerie im Lenbachhaus, Munich

ors become clearer, moving away from their motley application toward more accentuated primaries. Contrasts are now better resolved, the contour of the sky is emphasized, and objects cast deeper, more expressive shadows. By way of a reference to Neo-Impressionism, there are occasional mosaic patches. All of this results in a stronger organization of the pictorial surface and begins to hint at contents other than those depicting the natural scene. Most important, the concern with verisimilitude gradually yields to the increasing freedom and intensifying expressiveness of the pictorial means themselves. The result is a blurring of nature's recognizable features, while autonomous colors and shapes assert themselves in their own right.

In 1910, Kandinsky completed the first three of the group of programmatically structured works he called Compositions—a term he reserved for only ten oil

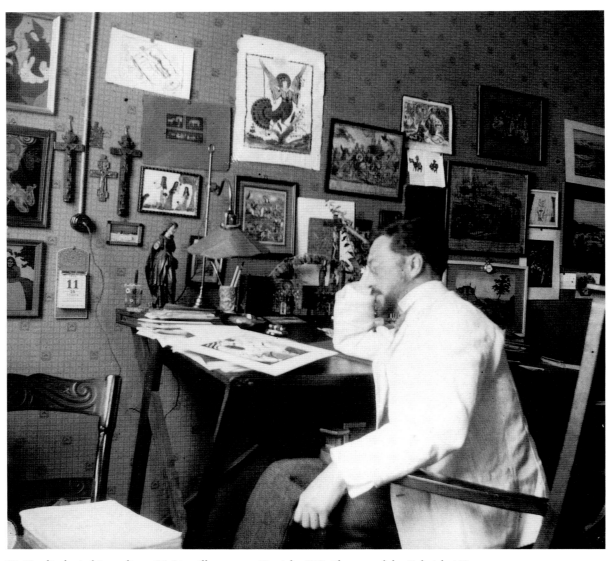

13. Kandinsky in his studio at 36 Ainmillerstrasse, Munich, 1913. Photograph by Gabriele Münter

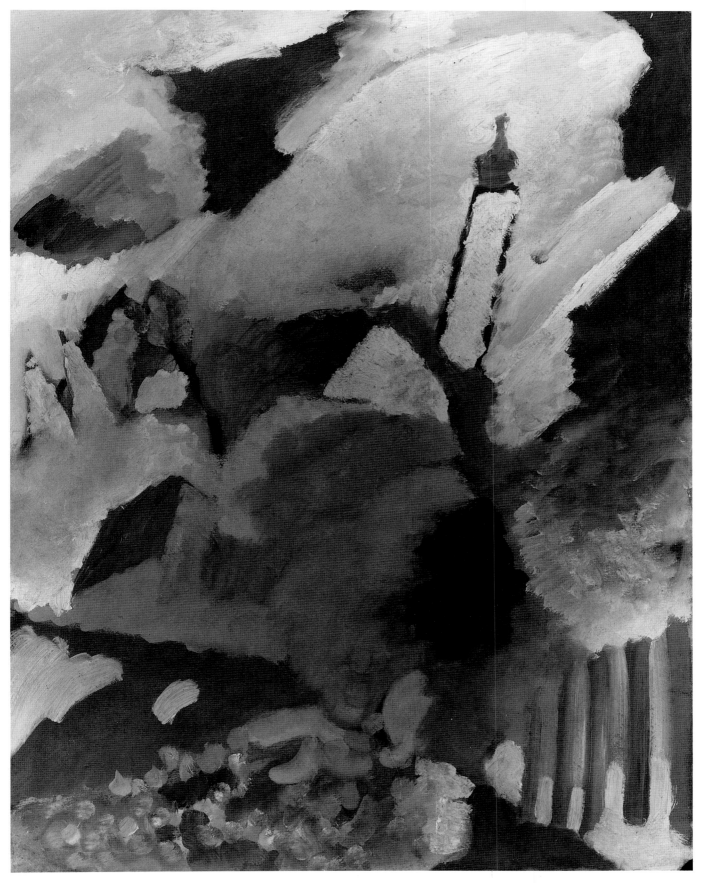

14. *Murnau with Church I.* 1910. Oil on cardboard, 25½ × 19¾″ (64.7 × 50.2 cm). Städtische Galerie im Lenbachhaus, Munich

paintings in his entire oeuvre and which he himself saw as summaries of slowly acquired visual experiences. Kandinsky now stood on the verge of his central contribution—the convincing projection of different levels of reality through forms that have detached themselves from their descriptive function.

•

Undoubtedly, this is the Kandinsky who most forcefully captured the imagination of his contemporaries and left the deepest mark on art history, the Kandinsky of what his friend and biographer Will Grohmann identified as the *Geniezeit*—the "genius span." It is the Kandinsky of the "heroic" years, as the period of his cultural leadership in Munich before World War I, from 1909 to 1914, is often called. It was then that his wide-ranging influence—as a practitioner, theorist, and polemicist, and as a leader of avant-garde movements—reached a pitch of intensity never to be equaled thereafter.

During his mid-forties, Kandinsky had arrived at full artistic maturity and was for the first time in a position to bring into play, on a grand scale, his impressive multiple talents. The relative isolation in which he had prepared himself now ended, as Munich became the main theater of his activities. At the onset of his second decade there, the capital city of Bavaria did not stand in the forefront of modernist endeavors, being hampered by a provincialism and philistinism that projected loudly through local reviews and conversations about the arts. But there was also an awareness of vanguard developments in German-speaking countries, and these, to some degree, were emulated. In addition, Munich could rely on an intellectual elite, which in Schwabing retained a distinctly bohemian coloring. Nor was it without the modernist aspirations for art evident in other parts of Central and Eastern Europe, including Russia. These ambitions had their roots in the nineteenth century, when the first conspicuous efforts to break away from traditional styles and to open up new horizons for artists became apparent. Such twentieth-century movements as the Brücke in Dresden and the Secessions in Berlin and Vienna, as well as analogous trends in Saint Petersburg and in Moscow, tried to achieve a stylistic reorientation by separating themselves from forerunner organizations that had once been regenerative themselves but had lost their edge.

It was under such circumstances that Kandinsky could move into a commanding position. Relying on a solid theoretical foundation, and with a newly gained power of pictorial expression, he was able to exert considerable influence on many levels simultaneously. His already tested organizational and promotional talents helped bring into being two successive art associations devoted to raising the aesthetic consciousness of conservative Munich. Both, but particularly his second effort, were as influential as they were ephemeral. First came the Munich New Artists' Association (Neue Künstlervereinigung München), which preceded the better-known, more innovative plan to publish an "almanac" and organize exhibitions, launched under the emblematic designation of the Blue Rider (Der Blaue Reiter).

Kandinsky was of course not alone in his modernizing efforts as a painter and, as these got under way, not without friends. Apart from Münter, the inner circle, for a time at least, counted among its members Kandinsky's fellow Russians Alexej Jawlensky and Jawlensky's painter friend Marianne von Werefkin (or Verefkina). At a later date, the young August Macke and the only slightly older Franz Marc added themselves to a like-minded group of friends that included as well the composers Arnold Schoenberg, whose presence was rendered more meaningful by his strongly developed avocation for painting; and Thomas von Hartmann, who became one of Kandinsky's few intimate friends. Toward the end of the Munich period, the Swiss-born Paul Klee was introduced to Kandinsky as well, but their fruitful friendship was not to develop until a later era, some years after World War I.

To the artists here mentioned, Kandinsky was understood to be distinctly senior. This was true not only because of the visible evidence furnished by major works from his hand, but also because his voice, as critic, commentator, and advocate of modernism, was by far the most articulate. Furthermore, his experience with organizational work, dating back to his activities at the by now defunct Phalanx school, combined with his tactful, diplomatic personality, made him the self-evident candidate for leadership in the organizing efforts at hand. Thus in 1909, the New Artists' Association promptly elected him its president—a charge that he fulfilled until it became obvious that the tensions between the organization's rather conservative membership and his own radicalism could no longer be bridged. In December 1911, he finally resigned from the Association, followed by Münter, Marc, and the artist Alfred Kubin. But his following organizational effort, the Blue Rider, though also short lived, was to win a permanent place in the annals of modern art.

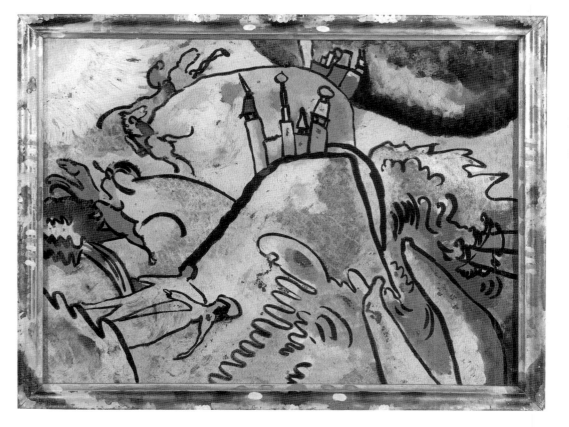

15. *Glass Painting with Sun*. 1910.
Painting on glass,
12¹⁄₁₆ × 15⁷⁄₈″ (30.6 × 40.3 cm).
Städtische Galerie im
Lenbachhaus, Munich

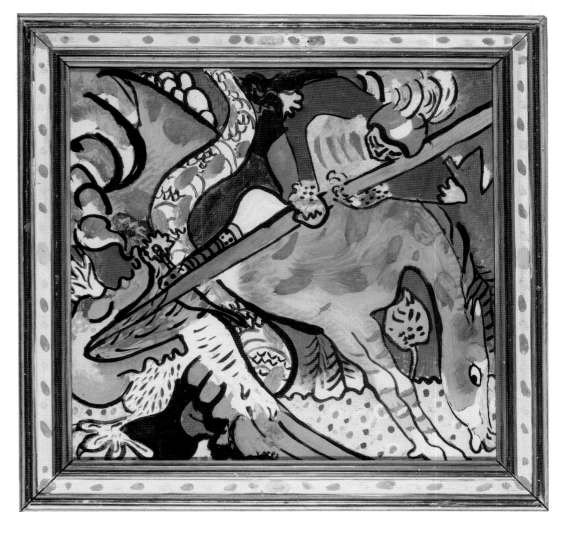

16. *Saint George I*. 1911.
Painting on glass,
7⁵⁄₈ × 7¾″ (19.3 × 19.8 cm).
Städtische Galerie im
Lenbachhaus, Munich

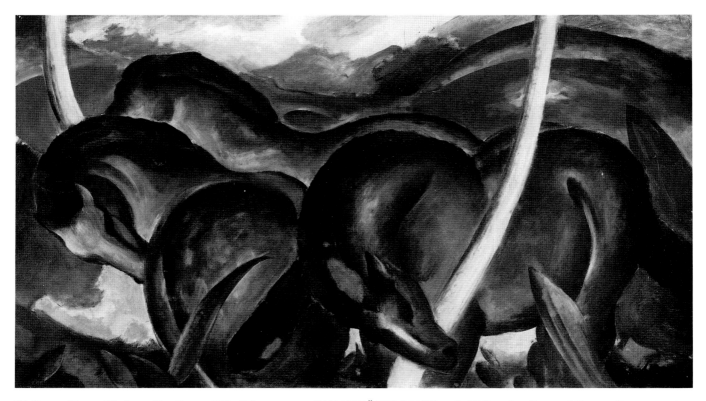

17. FRANZ MARC. *The Large Blue Horses.* 1911. Oil on canvas, 41¼ × 71½" (104.8 × 181 cm). Walker Art Center, Minneapolis. Gift of the T. B. Walker Foundation, Gilbert M. Walker Fund

Unlike other Secessionist initiatives, the Blue Rider was not an artistic "movement" in the ordinary sense of that term. It was, rather, envisaged as a didactic effort to counter the very notion of there being exclusively one valid approach to modern painting. It did this by stressing the variety and multiplicity of creative processes, including the arts of many different cultures. Kandinsky's interest in folk art, for example, led him to imitate in a number of his own works the local Bavarian practice of painting on glass (see figures 15, 16). But while it is true that the proposed exhibition and publishing activities were to be diversified and tolerant rather than parochially restrictive, it is also quite obvious that the core group, gathered around Kandinsky and exhibited in the two Blue Rider exhibitions, did produce works in which a certain family resemblance—distinct from the paintings produced either by the Brücke or the various Secessions—is difficult to miss. The stylistic affinities among some of the artists associated with the Blue Rider did in fact confer on them a determinable group identity. This pertains particularly to Münter, Jawlensky, Werefkin, Macke, Marc, and even Klee, as well as to a host of marginal figures.

Kandinsky conceived and executed the Blue Rider projects in collaboration with Franz Marc, whom he

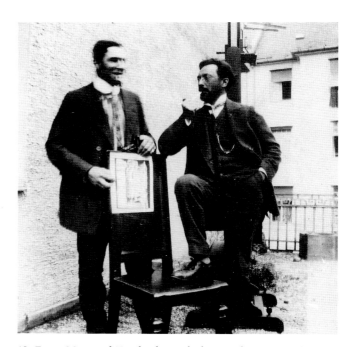

18. Franz Marc and Kandinsky with the woodcut cover of *The Blue Rider Almanac,* 1911–12

had met at the beginning of 1911. It was Marc's partiality to horses as a subject for painting (see figure 17), together with Kandinsky's own love for the subject of riders, as well as their shared enchantment with the color

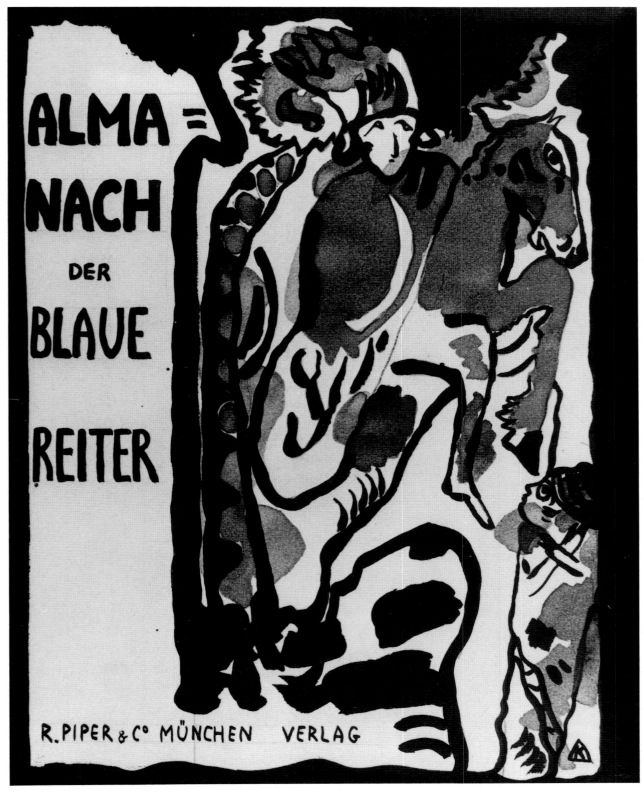

19. Final study for the cover of *The Blue Rider Almanac*. 1911. Watercolor, ink, blue pencil, and pencil on paper, 11 × 8⅝″ (27.9 × 22 cm). Städtische Galerie im Lenbachhaus, Munich

blue, that is said to have given the endeavor its name. In the summer of 1911, Kandinsky and Marc worked together on the publication known as *The Blue Rider Almanac* (see figure 19), which was destined to become a milestone in the documents of twentieth-century art. The *Almanac* would not actually appear, however, until the spring of 1912. In the meantime, after the breakup of the New Artists' Association in December 1911, the

two editors of the forthcoming *Almanac* quickly organized an exhibition, under the aegis of the Blue Rider, which opened in late 1911. It was followed by a second Blue Rider exhibition early in the following year.

The program of the Blue Rider was expected to continue through invitational exhibitions as well as through the serial publication of further almanacs. For various reasons, however, ultimately including the outbreak of World War I, the execution of this long-term concept never went beyond the first two exhibitions and the single almanac. Yet its premature demise did little to diminish the lasting effects of the initiative, in which Kandinsky had played the leading role. *The Blue Rider Almanac* thus remains a testament to Kandinsky's thinking in the Munich years. His written contributions to the volume far exceed in substance and length those of all the other writers, and the *Almanac*'s concept itself clearly bears the marks of his determining authority.

Although the preparation of the *Almanac* coincided with an exhibition—organized by Kandinsky and Marc at the Moderne Galerie of Heinrich Thannhauser in Munich—it cannot be described as an exhibition catalogue per se; instead, it was intended to present the rationale underlying the exhibition advertised in its pages, containing work by "Principal Masters, Artists of the Secessions, Modern Frenchmen, and the Blue Rider." Kandinsky's major essay, "On the Question of Form" ("Über die Formfrage"), is followed by his article on stage composition and by the scenario of *The Yellow Sound (Der gelbe Klang),* his most fully developed theatrical work.

"On the Question of Form" in the *Almanac* closely follows the thesis articulated more extensively in his principal theoretical treatise on abstract painting, titled *On the Spiritual in Art (Über das Geistige in der Kunst),* published a few months earlier. Honing the arguments there presented and, if anything, intensifying his didactic fervor, the author of "On the Question of Form" reiterates his faith in a new spiritual reawakening of humankind, while emphasizing that what he calls "inner necessity" (*innere Notwendigkeit*) is the only permissible motivation for all creative pursuits. As for the so-called "question" of form, Kandinsky maintains that, in principle at least, no approach to form is inherently superior to another, nor are the creative means used by any one artist generally applicable. Thus, "realistic" painting is no better or worse than "abstraction." But either of them can be corrupted—the former by a too rigid adherence to external appearances, the latter by reducing itself to mere decoration. Apart from such misuse, however, these two opposite formal tendencies are, in Kandinsky's view, not only theoretically equivalent but, in the end, identical. There is, therefore, no issue of form between them, Kandinsky concludes. Yet at the same time, Kandinsky viewed "abstraction" in evangelical terms; his professions of tolerance toward all art forms did not prevent him from continuing to argue the preeminence of abstraction and prophesying its ultimate triumph.

The two shorter items from Kandinsky's pen also return to a subject broached in *On the Spiritual in Art,* the investigation of other creative mediums. As indicated in *On the Spiritual,* the author envisaged an art form, presentable on the stage, that would exceed the potential of drama, opera, and ballet as they then existed. While insisting on the autonomous and separate expressive capabilities of music, color, and movement, Kandinsky nonetheless conjectured a synthesis of these complementary elements that would allow them to coexist on equal terms, without the subordination of one to the other. In this context, he credited Richard Wagner with originating the concept of the "total work of art" (or *Gesamtkunstwerk*), but faulted him for allegedly achieving such a fusion on only a superficial level, and to the detriment, moreover, of the inner values inherent in each of the component arts. The scenario of *The Yellow Sound,* the last of Kandinsky's contributions to the *Almanac,* provides a kind of alternative to Wagner and a prototype for modern stage productions. It argues for a deeper aesthetic synthesis, which is to substitute itself for a merely external combination of diverse arts.

Among the other contributors to the *Almanac,* Franz Marc, as Kandinsky's co-editor, wrote three brief pieces in which he recited the terms of what today may strike us as a rather conventional advocacy of modern art and defense of the rare creative individual. August Macke wrote "Masks," taking the subject in an anthropological sense; Arnold Schoenberg contributed an article on music, called "The Relationship to the Text"; and Thomas von Hartmann, the other composer associated with the Blue Rider, mused about "Anarchy in Music," strictly along the lines of Kandinsky's own theories. Throughout the *Almanac*'s pages, painting, music, and an innovative notion of stage composition (the last of these also dealt with by Leonid Sabaneev, a Mussorgsky student, in an article on Aleksandr Scriabin's "color symphony" *Prometheus*) constituted the main subjects. All but two of the articles were written by practicing artists or composers, in keeping with Eugène Delacroix's dictum, quoted in the *Almanac:* "Most writ-

ing about art is done by people who are not artists: thus all the misconceptions."

•

The Blue Rider enterprise coincided with the publication of Kandinsky's treatise *On the Spiritual in Art*—a short book that argued the case for abstract painting, with particular emphasis on the communicative properties of color. Based on notes made over the course of several years, the text voiced the artist's convictions about the as yet unattained potential of abstract painting. *On the Spiritual* thus amounts to Kandinsky's humanistic credo, stating his belief in the ultimate triumph of the spiritual over the material. Together with his main contribution to *The Blue Rider Almanac,* just discussed, which deals specifically with the issue of form, it constitutes the artist's principal theoretical statement about the art of painting in his time. The book was written for the most part in 1910; the first edition was published in December 1911 (although the date 1912 appears on the publication itself), and it was followed in short order by a second edition, containing some modifications. The text has an introduction by the author and is divided into two parts, one reserved for general issues, and the other, titled "Painting," devoted to the subject of color. Each of these parts contains four chapters (counting the introduction as one). Kandinsky provided ten woodcut vignettes by way of illustration as well as a larger woodcut for the cover.

From the outset, Kandinsky's text situates the artist on the high plateau of the "spiritual," which, throughout the volume, is contrasted with the debased values of nineteenth-century materialism. Optimistically and confidently, Kandinsky expects the dawn of an era in art and life that will promote inner, more deeply human values over external and mechanistic ones. Implicit in such a shift is the understanding that "form" (or what today we would call "style") is merely a device through which the artist's creative intentions are realized. In choosing the form best suited to his inner needs, therefore, the artist must be free from any outside compulsion. There should be no limits to this freedom, Kandinsky argues, except those imposed by "inner necessity," which throughout *On the Spiritual* is identified as the basis of creative motivation. All is permitted in art, as long as it springs from inner necessity. The text of *On the Spiritual* reiterates this again and again.

Such an insight invalidates any fixed standard of beauty that would regulate the painter's pursuits.

Borrowing from music to support this view, Kandinsky, agreeing with Schoenberg, dismisses the very notion of "dissonance," for example, as arbitrary and relative since, once again, only inner necessity—that is, the composer's deeply felt creative urges—can determine what to him constitutes an appropriate aesthetic entity. Parallels between painting and music are pursued throughout Kandinsky's book because music was often seen as the most spiritual art form, the one best suited to expressing the ineffable. It is the art form least encumbered by irrelevant side effects, free to concentrate on its own expressive concerns. But the author of *On the Spiritual* also moves beyond these particular parallels to draw comparisons between, for example, painting and literature, analyzing the capacities of forms and colors in relation to the word, and drawing further analogies with modern dance. For the future, he foresees a "monumental" art form (or *Monumentalkunst*) for the stage, in which color and form, sound and the movement of dance, would complement one another without thereby losing their specific characters or capabilities (a topic he returned to in *The Blue Rider Almanac*).

The central issue of Kandinsky's essay, however, is abstraction, which he sees as the harbinger of the new spiritual age to come. The volume's second part, devoted in the main to the physical and psychological properties of color, provides the more concrete argument in this respect. It insists on the autonomous "content" of color, which exists quite apart from color's function in describing objects. Each color, Kandinsky writes, has its own objectively verifiable properties and its own specific effect on the psyche. Colors interact with each other, like living things, and at the same time they maintain a controllable balance with particular shapes, such as the triangle, the circle, and the square. Given these properties, color can be structured in a systematic manner and harnessed to produce predictable responses. Eventually, therefore, the interactions of colors and forms may be rationalized into a kind of pictorial grammar, analogous to the codification of tonal relationships that Schoenberg articulated in his book *Theory of Harmony (Harmonielehre),* published in 1911 and written almost simultaneously with *On the Spiritual in Art.*

It is important in this connection to understand that Kandinsky approached the subject of abstraction in painting with due caution, both in his own work and in his theoretical statements. He was fully aware of the danger posed to his ideas by the merely ornamental—that is, by a form of abstraction without a convincing

20. *Picture with a Circle.* 1911. Oil on canvas, 78¾ × 59″ (200 × 150 cm). The State Art Museum of Georgia, Tbilisi

content. But he was at least equally critical of painting restricted to a narrative, representational scope and devoid therefore of an essential spiritual dimension. A valid artistic expression must avoid both pitfalls, the author of *On the Spiritual* maintains. It is illuminating to note in this context Kandinsky's sense that the time for pure abstraction—for painting that would function entirely apart from the object—had not yet come. It was, however, a reservation that he was soon to abandon (see figure 20).

The ability of a visual language to carry meaning without referring to specific objects is the aspect of Kandinsky's art that preoccupied him all his mature life. This is true from the moment in his youth when he was captivated by a Monet painting, which at the time seemed to him devoid of the objective world's familiar features, to his very last works in Paris, when he seemed to grope for more palpable elements to include in his art that would, nonetheless, remain compatible with the rest of his lifework. His exploration of the world's visual forms led Kandinsky to conclude that the realm of art and the realm of nature are separate, and that instead of fighting a losing battle to imitate the appearance of God's creation, painting must proceed on its own parallel but independent path. For Kandinsky, this goal was not fully achievable through either the attenuation or the reduction of forms, merely thinning them out, so to speak, or simplifying them; it required the complete dissolution of familiar imagery into wholly autonomous colors and shapes. It was as if the elements in his paintings, instead of telling us about some object in the world, were now to speak for themselves.

Throughout the Munich period and possibly beyond it, the search for a self-sustaining pictorial language varied the painting's distance from the objective world. The painter strains away from the object, trying to transcend it, yet still remains mostly within its orbit. As a result, the relationship between the artist and the viewer is subject to tension, in a manner both exhilarating and frustrating. That is, the artist tends to ascribe to his forms something other than objective origins, while the viewer persists in identifying and naming the vestigial elements able to be recognized. Too close an approximation of image to object subverts the artist's intention; too much distance from the object may leave the searching viewer unsatisfied. Therefore, a certain ambiguity, an oscillation between one level of reality and another, characterizes Kandinsky's art before World War I. And even afterward, in what would appear to be a wholly non-objective, geometric phase, models from nature linger in a sublimated state as their defining outlines are subsumed into seemingly free forms.

•

Given the artist's preference for undisclosed meanings in his art, for reticence and ambiguity, we are quite naturally driven to consult writings such as *On the Spiritual* for clarification. But here, even as one admires

21. Kandinsky with *Small Pleasures* (oil painting related to figure 15), Munich, 1913. Photograph by Gabriele Münter

Kandinsky's literary talent and his methodical and pedagogic turn of mind, the perusal of the texts remains difficult. The artist's prose style is generally evocative rather than explicit, paralleling his stated aim as a painter, to speak "mysteriously about the mysterious." Moreover, Kandinsky relied on a vocabulary that harks back to Goethe and to Nietzsche, operating with German philosophical terms such as *Geist* ("spirit"), *Seele* ("soul"), *Wesen* ("being"), *Gemüt* ("disposition"), *Gefühl* ("feeling"), *göttlich* ("divine"), and other similarly encompassing words whose connotations translate only approximately from one culture and age to another. They are not without problems for the modern reader. Such a vocabulary must therefore be understood as reflective of a Slavic and Germanic ethos and, beyond this, as consonant with nineteenth-century ways of thinking rather than with modern usage.

As for the texts themselves, Kandinsky, writing copiously, devotes much thought to the purpose and nature of his work, articulating his intentions and desired results with deliberation. In elaborating his

theories, he freely combines metaphorical language with pseudoscientific procedures. Consequently, he often moves rather heavily from thesis to antithesis to synthesis, carefully numbering each step and deriving from the resulting sequence of intuitions the kind of "law" that is normally found only in mathematics or geometry. The texts are largely didactic and at times polemical defenses of his work and of abstraction and "pure" painting in general, and their subject matter is therefore rather circumscribed and often repetitive. The occasion and the audience may vary, but what Kandinsky has to say moves within a fixed radius that is only rarely extended. The themes that appear and re-appear relate to the creative process, with consistent emphasis on its inward nature. Thus, distinctions are made, and frequently reiterated, between the hidden content of art and its exteriorization through aesthetic form. Creativity is conceived as a dialectic between reason and feeling or, more familiarly, between head and heart. And underlying all, an evangelical faith in an approaching millennial age of synthesis, going beyond the realm of art itself, is contrasted with a critique of the preceding century's materialism.

•

Despite Kandinsky's involvement with *The Blue Rider Almanac* and his writing *On the Spiritual in Art,* the achievements of the "heroic" years were no longer predominantly theoretical. More important was the impressive number of major canvases and works on paper upon which, in the end, Kandinsky's fame rests. Through such works as *Lyrical* (plate 13), *Composition IV* (plate 15), *Composition V* (plate 16), *Painting with Black Arch* (plate 19), *Composition VI* (plate 20), *Painting with White Border* (plate 21), and *Composition VII* (plate 23), the painter manifested his faith in the validity of the abstract mode. These are also, in terms of art history, the works that, more than anything preceding or fol-lowing in Kandinsky's oeuvre, blazed new trails and had a far-reaching impact. With them, the artist reached a level of maximal inventiveness, accompanied by a sense of being alone and ahead of the pack. While this was to some extent a subjective perception, the fact remains that Kandinsky's paintings of the immediate prewar years are attainments of provocative daring that only the passage of time has since converted into readily accessi-ble works of great beauty.

In his major efforts between the initial burst of pro-ductivity at Murnau in 1908 and the collapse of such

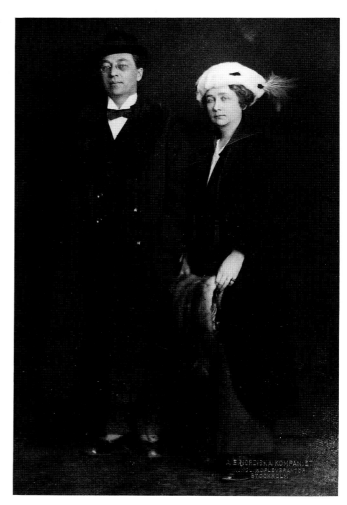

22. Kandinsky and Münter in Stockholm, 1916

endeavors at the outbreak of World War I in 1914, the notions proposed in *On the Spiritual* were put to the test. For it is in these paintings that explicit content is gradually dissolved, while the object itself, deprived of its defining outline as well as its familiar context, retains no more than a vestigial existence, on the verge of dis-appearance. And it is in these paintings too that the hid-den contents which define and determine Kandinsky's art reach their greatest expressive power.

RETURN TO RUSSIA

The heady momentum of the Munich years, both with respect to Kandinsky's own initiatives and the ferment of the avant-garde as a whole, could probably not have been sustained for much longer. But instead of leading gradually into other, slower currents, the "heroic" peri-od was terminated forcibly by the imperatives of broad-er developments outside of art. On August 3, 1914, World War I broke out, putting an end to peaceable

pursuits. Russia and Germany, Kandinsky's two worlds, came to confront each other on the battlefield, and the artist, now considered an enemy alien, had to leave Munich virtually overnight for neutral. Switzerland, rearrange his life, and improvise plans for the immediate future.

He could not have foreseen the fateful changes, personal, political, and creative, that a seven-year absence from Germany would entail. It is clear in hindsight, however, that the Russian interlude—his Moscow years of 1915–21 (which followed a sojourn in Switzerland after his leaving Munich, and included a stay in Sweden in early 1916)—became the point of departure for renewed creative accomplishment in the years after the war. By the time of Kandinsky's eventual return to Germany, at the end of 1921, his work would undergo radical changes, reflecting new ideas. It would bear virtually no resemblance to the work of his Munich years, to the point of not being easily identifiable by those without access to the intermediary development. His search for an autonomous language based on free forms and expressive colors had moved to a different level, and its imagery no longer remained close to the borderline between palpable reality and abstraction. Only a few traces remained of the effort to relate natural appearances to the exigencies of pure painting. Instead, a style emanating from geometry made possible a new visual order hitherto beyond the artist's range or need.

This developing reorientation, strongly foreshadowed in the war years and their immediate aftermath, was predicated more on the faculty of reason than upon spontaneous emotional responses. Resulting from larger shifts in philosophical and political ideas, Kandinsky's new art was profoundly involved with a collective change in ways of thinking fated to take possession of Europe. In the most general of terms, such a change amounted to a swing of the pendulum from Romantic to Classical ideals, an age-old polarity that was newly embodied by the contradistinction between Expressionism and Constructivism.

•

After witnessing the October Revolution in 1917 with Nina Andreevskaia (see figure 23), his new bride, Kandinsky became actively engaged in the new Soviet state's redefinitions of education and culture. His undeniably significant contributions during his Moscow sojourn of 1916–21 were, however, less clear cut than had been his unchallenged intellectual leadership in

23. Nina Andreevskaia, Moscow, c. 1913–14

prewar Munich. This is partly due to the fact that the developments themselves, in particular the emergence of what we now identify as the Russian avant-garde, resulted from complex and contradictory currents, as the position of the contemporary artist was adjusted to the new sociopolitical realities. Following the demise of Czarist cultural paternalism, new structures had to be created, in the midst of political flux. These had to be acceptable both to the still-shaky power structure within the emergent Soviet state and to various, often mutually incompatible, artist groups.

Efforts at the state-guided reorganization of culture started in 1917, after the Revolution, under the overall auspices of the People's Commissariat of Enlightenment, known as Narkompros. Despite widespread opposition to state-controlled culture, many prominent artists, including Kandinsky, joined the Commissariat's Department of Visual Arts in Moscow (see figure 24), which was chaired by Vladimir Tatlin, arguably the most radical artist of the Revolutionary generation. By the end of 1918, the museum department of Narkompros had conceived of "museums of artistic culture," to be set up in various parts of the Soviet Union to further mass education through various exhibitions and the collecting of contemporary art, purchased with state funds.

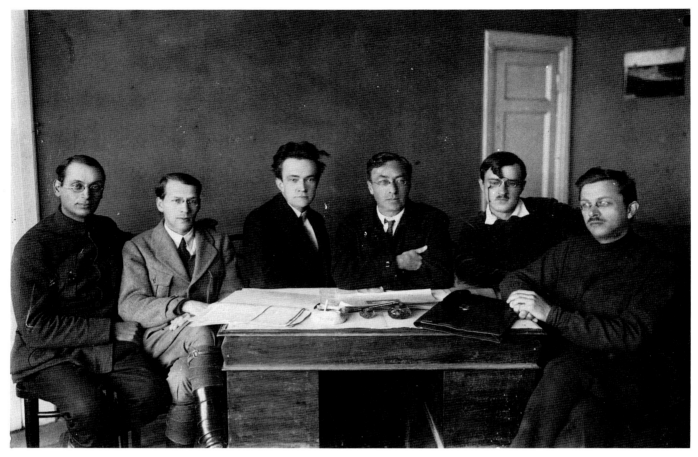

24. Kandinsky with members of Narkompros, Moscow, c. 1920–21. Left to right: the painter Robert Falk; the violinist Shor, the physician Petr Uzbensky; Kandinsky; the choreographer Pavlov; and the composer Aleksandr Shenshin

The continued striving for autonomy of the arts and for freedom for artists, promoted actively within professional unions, also set the stage for the creation of Inkhuk, the Institute of Artistic Culture, which was designed to investigate "objectively" the elements constituting the creative process—a subject very close to Kandinsky's heart. Thus Kandinsky, who was involved in the creation of Inkhuk in 1920, became its first chairman and used his position to define the organization's aims and objectives in the following, highly theoretical terms: "It [Inkhuk] will collect experiments in formal construction according to the principle of juxtaposition: color, planes and linear planes; the alignment, collision, and resolution of planes; the relation of surface plane and volume as self-sufficient elements; the coincidence or disconnection of linear and painterly planes and volumes; experiments in the creation of purely volumetric forms, both unitary and combinational, and so forth." These, however, were not objectives with which Inkhuk's younger members could identify. Acrimonious debates ensued between Kandinsky and his fellow artist and erstwhile friend Aleksandr Rodchenko. While Kan-

dinsky wished to emphasize physiological and psychological responses to color, Rodchenko and his circle stressed the primacy of "structure" and "rhythm," concepts that were to become central to Constructivism and to Productivist art. As events unfolded, Rodchenko was first given authority to preside over an Inkhuk committee to function in "parallel" fashion with Kandinsky's, and eventually replaced him, on Kandinsky's resignation.

Behind the clash of professional views and personalities one may conjecture that Kandinsky, for many years an expatriate and now in his early fifties, would be hard pressed to find common ground with his younger compatriots at this critical moment. Despite his avant-gardism, he was by background bourgeois, in the best sense of the word, and not even his demonstrated talent for assimilation would have enabled him to move in unison with political trends that his accumulated wisdom and detached temperament could not help but view with skepticism. It is not surprising, therefore, that with the onset of the 1920s, a time of further radicalization of the cultural climate, Kandinsky would begin

to withdraw, first from his public charge and then, in December 1921, from the Soviet Union altogether.

•

For more than a year after his departure from Germany, Kandinsky did not paint at all, and during the period of his active political engagement in Moscow—that is, from late 1917 to late 1921—his artistic production remained fragmentary. Altogether, some ninety paintings, including those on glass, are extant from the years between 1916 and 1922, and while among these there are isolated examples of outstanding quality, they are rare. The causes for such retrenchment are to be found both in the prevailing worldwide turbulence of the times and in Kandinsky's unsettled life. The heavy schedule imposed on the artist by his public commitments left him with little free time at his disposal. Then too, the emotions generated by the separation from Gabriele Münter and his subsequent marriage to Nina Andreevskaia, at the time no more than half his age, needed to be calmed, and later on, the loss of Vsevolod, the Kandinskys' three-year-old son, caused sorrow and

suffering. It is not surprising, then, that the artist's concentration would be impaired and that this would be reflected in a somewhat fitful and unfocused production.

There were, nonetheless, some outstanding examples in the first years of Kandinsky's return to his native country, such as *Painting on Light Ground* (plate 26), *Twilight* (plate 27), and *In Gray*. But there were also uncertain reminiscences of prewar days, repeating in diluted form themes from *Small Pleasures* (see figures 15, 21) and other major works. Rather prosaic views of Moscow as seen from the artist's apartment window were followed by landscapes of the Achtyrka surroundings that look like throwbacks to much earlier, long abandoned pictorial efforts. The year 1918 again shows no painting at all, unless one were to count no fewer than sixteen glass paintings with superficial, fashionable themes, works that were probably produced for the market—understandably so, to be sure, considering the prevailing conditions of privation.

But already toward the end of the decade, Kandinsky's work appeared newly charged (see figure 25). The remaining amorphous forms of the prewar style began to alternate with an imagery contained within clearly

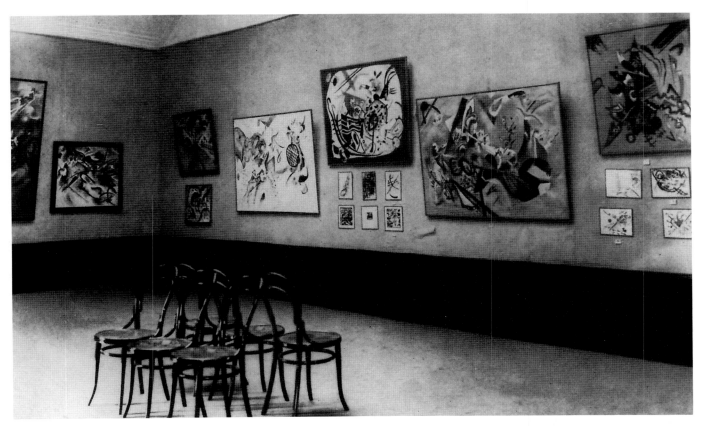

25. Kandinsky's second and last exhibition in Moscow, at the "XIX Exhibition of the Pan-Russian Central Exhibiting Bureau," 1920. From left: *Composition VII* (plate 23), partially visible; *Sketch (Red with Black)* (1920); *Landscape (Dünaberg near Murnau)* (1913), above, and *Black Lines II* (1920), below; *Pointed Hovering* (1920); *Painting with Green Border* (1920), above six works on paper; *In Gray* (1919); and *Points* (1920), above four works on paper.

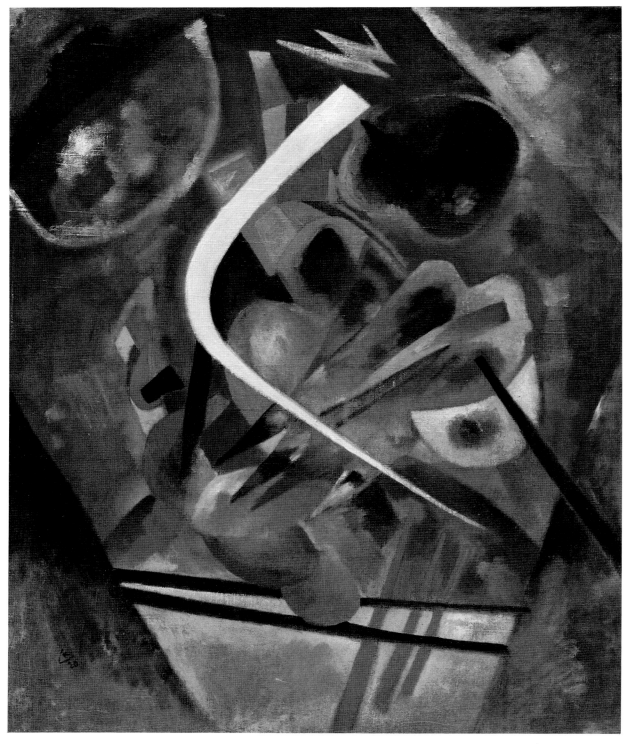

26. *White Line.* 1920. Oil on canvas, 38⅜ × 31½″ (98 × 80 cm). Museum Ludwig, Cologne

defined outlines, as the stage is set for more condensed formal solutions. In the new decade, such highlights as *Red Oval* (plate 28), *White Line* (figure 26), *Red Spot II* (plate 29), and *White Center* signal an upturn in communicative intensity. Besides a marked increase in the number of works produced, we now see newly defined shapes floating in space or purposefully encased. The perfect circle, an image that will assume centrality in subsequent years, makes its first appearances (see figure 27).

The paintings and watercolors completed by the artist during his turbulent stay in Russia mark the Revolutionary years as a time of fruitful reflection more than one of distinguished production. Kandinsky had occasion to reconsider his priorities and come to fresh con-

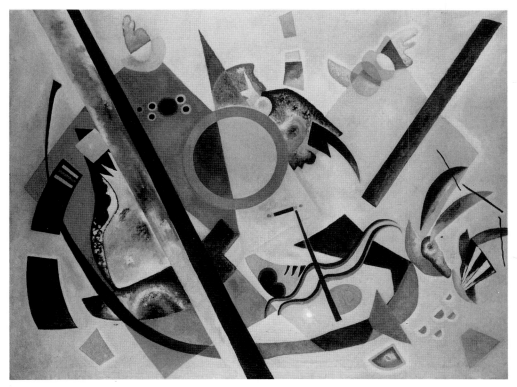

27. *Multicolored Circle*. 1921. Oil on canvas, 45½ × 70⅞″ (138 × 180 cm). Yale University Art Gallery, New Haven, Connecticut. Collection Société Anonyme

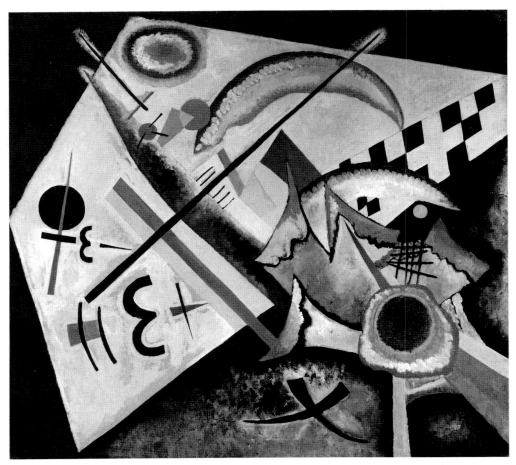

28. *White Cross*. 1922. Oil on canvas, 40⅝ × 43½″ (103 × 110.5 cm). The Solomon R. Guggenheim Foundation (Peggy Guggenheim Collection, Venice)

clusions. His new creative thinking had its roots in the late Munich years but was significantly accelerated by the aesthetic and intellectual conflicts played out in Moscow. From these, the artist emerged both defeated and enriched.

•

In his art and in his life, Kandinsky was multifaceted. A gracious, cultivated man of many talents, he was jealous of his privacy and difficult to know. His principles asserted themselves visibly in situations requiring tact and discretion, yet his personal conduct was not always above criticism. His rather cowardly abandonment of Gabriele Münter is difficult to excuse. More reprehensible yet was an alarming measure of naïveté in his political judgment, something that is hard to reconcile with his worldly wisdom. In the 1930s, the artist would take longer than most of his colleagues at the Bauhaus school to recognize and act upon the ominous developments in Germany. The Nazis had to assume power and force the closing of the Bauhaus before the Kandinskys would finally decide to move to Paris, "provisionally," as they thought, and in illusory expectation of a return when the situation in Germany would have somehow repaired itself.

Kandinsky's complicated disposition and his embrace of wide interests were expressed through his cosmopolitan openness to different cultures. They were ultimately reflected in a polyglot, multinational lifestyle encompassing, besides his native Russian, his subsequent German and French citizenship in the course of a politically unsettled existence. Kandinsky's movement from country to country over the course of several decades was motivated primarily by expedience, but it was also rendered tolerable, and indeed stimulating, by rich cultural affinities and by the artist's assimilative capacities.

Yet Kandinsky, born in Moscow of Russian parents, remained emotionally attached to his native land, most of all through his love for Moscow itself. The city of his birth enters into his work, both in its figurative likeness and in an abstracted, hidden guise. Slavic motifs appear frequently during the Munich phase, when Bavarian themes are Russified or, conversely, a Russian impulse is fleshed out with the objects at hand. The artist's predilection for colors and shapes vaguely identifiable as Slavic is evident in his early work and recurs to the end of his life. Kandinsky continued to cultivate Russian, his mother tongue, throughout his many years in

Germany and France. He formulated some of his more eloquent published statements in that language and spoke Russian whenever a suitable opportunity presented itself. Particularly in his old age, when a sizable community of Russian émigrés had gathered in Paris, his use of Russian was further increased.

At the same time, the artist's ties to German culture and language were extensive and profound. Kandinsky's family on his maternal side came from the Baltic region, which had traditional links to Germany, and Kandinsky's reliable command of the language dated back to his childhood. Moreover, owing to the divorce of his parents, the boy's upbringing was left largely to his mother's sister, who introduced him to the folklore and the fairytales common to Germanic and Slavic traditions. As for German literature and philosophy, Kandinsky as a student was bound to acquire the rudiments in the school in Odessa that he attended in his teens, a knowledge he extended in years to come. He would, moreover, spend a total of more than thirty years of his life in Germany, with the German Gabriele Münter at his side for half that time. And having forfeited his Soviet citizenship upon his departure from Moscow in 1921, the artist again took up residence in Germany, ending a period of statelessness by becoming a German citizen in 1928.

But for all that, Kandinsky's lifelong bond with "Mother Russia" was never truly severed. With such resulting ambivalence, pulled as he was between nations, Kandinsky could well have applied to himself Goethe's plaintive line: *"Zwei Seelen wohnen, ach, in meiner Brust"* ("Two souls dwell, alas, in my breast").

THE BAUHAUS

During a temporary stay in Berlin following his departure from the Soviet Union, Kandinsky was invited to join the Bauhaus through a telegram, signed by the director of the school, Walter Gropius, and by members of its illustrious faculty. Even though the Bauhaus was primarily oriented toward practical instruction in the applied arts, Kandinsky gladly accepted a teaching position that allowed him to pursue pedagogical and theoretical aims while returning to his own painting. He settled in Weimar, the institution's first location, in late 1922.

The Bauhaus derived its name from the German verb *bauen* ("to build") and the noun *Haus* ("house"). It began its fourteen-year history in 1919, under the super-

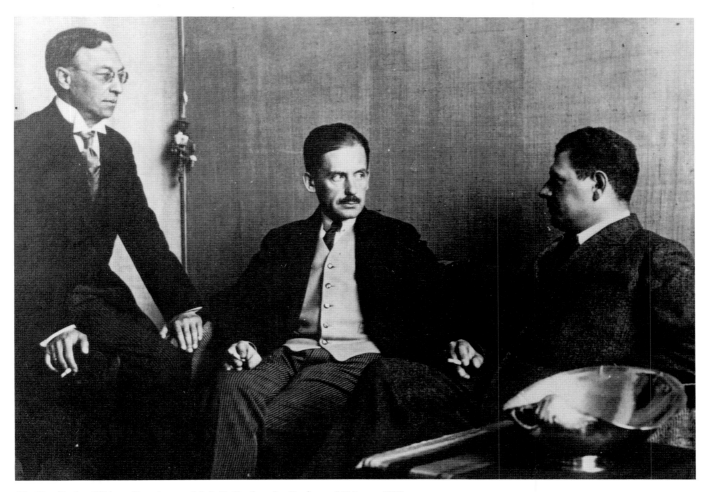

29. Kandinsky, Walter Gropius, and J. J. P. Oud at the Bauhaus, Weimar, 1923

vision of the architect Gropius, its founding director (see figure 29). Destined to change its location twice during its turbulent, politically vulnerable existence, the Bauhaus started out in the ancient town, associated with Goethe, in Thuringia, in the eastern part of Germany, later moving to Dessau and finally to Berlin. Gropius, a man of large and original vision, was not interested in setting up a conventional school of art or architecture, but rather in creating a didactic instrument that would establish new conditions for the education of artists. He saw, in the first instance, a need to reunite the fine arts with the crafts, or applied arts, which, to the detriment of both, existed in separation from each other. The fine arts, Gropius felt, were leading a charmed, otherworldly existence, remote from the practical requirements of the crafts; while the crafts, in turn, remained merely utilitarian, devoid of the attention to aesthetic form that could raise them to their full potential. To overcome this division, the Bauhaus

workshops in the various mediums—such as wood- and metalwork, printing and bookbinding, mural painting, weaving, and stagecraft, among others—were each to be guided by two "masters," one concerned with practical instruction in the prerequisites of craftsmanship, the other with the teaching of aesthetic form. Such simultaneous instruction was intended to create a new generation of artist-artisans who would encompass the hitherto separated areas of competence. Another effort at synthesis looked to the collaborative deployment of the different arts and crafts in joint endeavors, much as had been the case with the medieval cathedral builders, whose hierarchies and terminologies the Bauhaus adopted for its own use.

•

The Bauhaus could not, of course, remain unaffected by the changing times, which, as already noted with

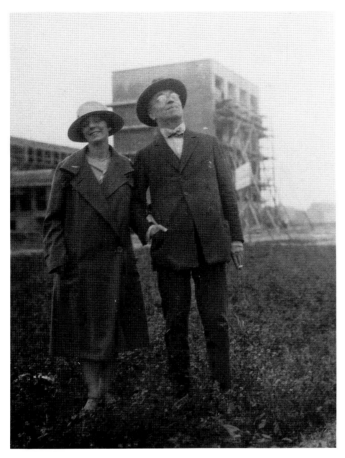

30. Nina and Vasily Kandinsky at the Bauhaus construction site, Dessau, spring 1926

1925–26, under more favorable conditions. Realizing one of Gropius's original dreams, the institution's program now could be conducted in its own buildings, which, with the help of public subventions, Gropius and his architectural firm completed by the end of 1926, less than two years after first arriving in Dessau (see figure 30). Through an ongoing process of redefinition, and even more through changes in personnel, the "Expressionist" Weimar phase had given way to a design identity that gradually replaced the increasingly dated features of the prewar epoch. Among the Bauhaus masters who had put their stamp on the Weimar phase, Itten had departed and the American Lyonel Feininger was no longer teaching. Besides Kandinsky and Klee, Oskar Schlemmer and László Moholy-Nagy were perhaps the most prominent holdovers from Weimar times to continue in Dessau. But a new generation of teachers and masters, some of them products of Bauhaus teaching themselves, now included Josef Albers, Herbert Beyer, and Marcel Breuer, among others. The architects Hannes Meyer and, eventually, Ludwig Mies van der Rohe, followed Gropius as successive Bauhaus directors after he resigned from that post in 1928.

Kandinsky, who in Dessau shared one of the newly built, two-family masters' houses with Klee (see figure 32), was only partially in tune with evolving Bauhaus trends. Since, from the beginning, the stated purpose of the institution excluded conventional art instruction, Kandinsky directed a workshop for mural painting in Weimar, while in Dessau he gave courses on analytical drawing and abstract form. Only beginning in May 1927, at his request, could he teach a painting class on his own terms.

With the move to Dessau, a sharply increased tempo in Kandinsky's production and a purposeful morphological development came almost immediately. While the first year of his return to Germany had yielded twenty-eight paintings, his output increased during the Bauhaus years to an average of more than forty, before it fell again with the dissolution of the institution. The quality of this work varied markedly (much as it did throughout his life), from rather arid theoretical exercises to sublimely evocative statements, but the 1920s present us with a consistent formal framework and a notable consolidation of abstract means. There are subtle changes in mood reflecting the inventive redeployment of pictorial devices from year to year. The earlier work in Weimar may differ somewhat from the later production in Dessau, but the Bauhaus creation as a whole remains homogeneous, and distinct both from

respect to the Soviet Union, witnessed a general swing from emotionally "expressive" to rationally "constructive" tendencies. Such a reorientation developed only gradually, however, so that the Weimar period of the Bauhaus, which lasted until 1925, was still seen in individualistic, expressive terms. Kandinsky's now decade-old text *On the Spiritual in Art* had been absorbed in the days of the Blue Rider by Paul Klee, now a Bauhaus colleague, as well as by Johannes Itten, a painter with distinctly mystical inclinations who exerted great influence during the institution's first years. A combination of philistinism and proto-Nazism in the provincial environment of Weimar rendered the Bauhaus leadership, and its partly leftist faculty and student body, suspect and vulnerable. During a time of general hardship, when a defeated Germany was beset by many woes, radical art and a life-style that sought a relaxed balance between work and play ran counter to accepted norms and soon engendered opposition to the Gropius project within Weimar.

Fortunately, following an invitation from the industrial city of Dessau, the Bauhaus could relocate there in

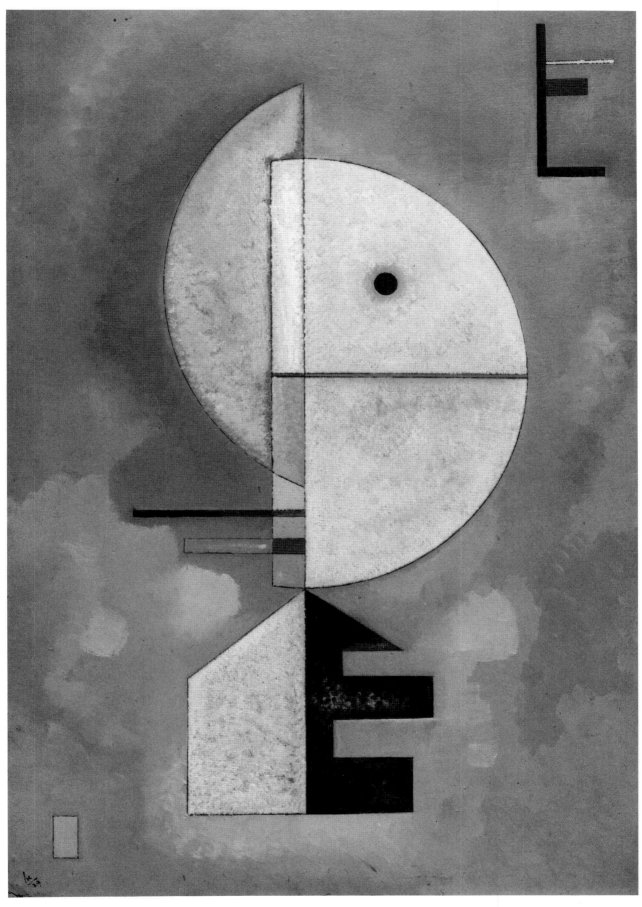

31. *Upward*. 1929. Oil on cardboard, 27½ × 19⅜″ (70 × 49 cm). The Solomon R. Guggenheim Foundation
(Peggy Guggenheim Collection, Venice)

32. Kandinsky and Paul Klee on the terrace of the masters' house in Dessau, 1930

his Expressionist past and from the biomorphic work that was to come.

•

Such important examples as *Blue Circle* and *White Cross* of 1922 (figure 28) still bear the marks of the Russian transition. But already in the following year, with major achievements like *Composition VIII* (plate 30), Kandinsky's Bauhaus style came fully into its own. Then and thereafter, the use of quasi-geometric elements grew more systematic, bestowing on the best works an equilibrium that is rigorously rational. Points, lines, and planes engage in a complex interplay with colors and textures, to yield tense surfaces charged with what are essentially abstract meanings—despite the associations evoked by the resulting images. Accompanying titles focus initially on color, form, or both. *Circles within a Circle, Blue Painting,* and *Pink Square* may serve as examples of this. At a later stage, titles tend to identify general conditions or moods: *Capricious, Becoming,* and *Brown Silence,* for example. The circle, which hitherto had made only tentative appearances in Kandinsky's

abstract compositions, becomes a central icon, to the point that some commentators have seen it as a surrogate for the horse-image of the Blue Rider period. Floating in isolation or in concentric arrangements, the circles that appear in the Weimar years remain prominent throughout the Bauhaus phase. Now, complex relationships arise among an increasingly prolific assortment of shapes. Wedges may pierce curved peripheries; the point of a triangle may come near to a circle, "like the hand of God as it approaches Adam's in Michelangelo," as Kandinsky said. Irregular grids, half letters, and abstract signs join imagery reminiscent of mountains, suns, moons, half-moons, and other, more ambiguous fragments. In rare instances, the developing iconography includes references to industrial forms, as in the architectural style of Purism, and, exceptionally, images appear to simulate the reductiveness of Neoplasticism or Constructivism.

The Dessau years represent, quantitatively at least, a highpoint in Kandinsky's work and a further deepening of his language of geometry. Despite common features, there is a perceptible morphological evolution from the first to the second Bauhaus location, as isolat-

ed dots and lines come to define Kandinsky's spaces. Dots and circular forms in Dessau carry implicit suggestions of constellations of stars and of planetary spheres. The initially often rigid geometry is softened in later years as planes seem to glide in space, rather than assume static frontal positions. Squares and rectangles increasingly yield to more polyvalent and irregular shapes. Checkerboards become attenuated and the single circle floating in space is complemented by elliptical and other curvilinear forms. Larger parabolic curves often replace the sometimes fussy minutiae of interlocking fragments. Straightedged forms and the angles created among them result in rhythmic patterns imbued with a sense of motion. All energy flows from predetermined points that, knotlike, hold together a dependent network of lines and planes. Superimposed planes create double or triple images that may remain separated from one another or, alternately, may be merged as the surface becomes a pulsating organism.

As we learned in *On the Spiritual,* color rendered in infinite nuances may either reinforce or counteract the vocabulary of shapes, as will textures—or *faktura,* in the more comprehensive term used by the Russian Constructivists. The graphic images developed during the Bauhaus phase contribute to a synthesis in which all the formal means participate, realizing the resulting work's full potential.

As the Bauhaus years advance, spatial dispositions, in particular the relation of planes to each other, become simultaneously more subtle and more defined. The plane becomes subject to vertical subdivision, thus creating contrast or harmony between the right and left

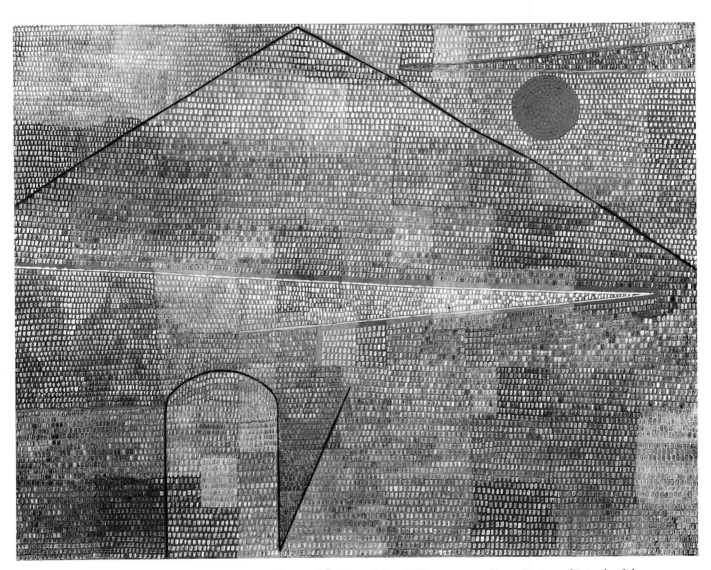

33. PAUL KLEE. *Ad Parnassum.* 1932. Oil on canvas, 39⅜ × 49⅝" (100 × 126 cm). Kunstmuseum Bern. Society of Friends of the Kunstmuseum Bern

34. Will Grohmann and Kandinsky in Berlin, June 1933

halves of the canvas. Hard or soft, straight or curved, solid or liquid edges are part of Kandinsky's striving for differing formal and emotional results. By way of example, *Several Circles,* in its final version of 1926 (plate 32), supports Kandinsky's confidence in the expressive power of non-objective forms. Defensively, yet perhaps not incorrectly, Kandinsky kept insisting that naturalism remained limited to the depiction of mere segments of nature. But as *Several Circles* shows, in his hands non-objective painting can indeed carry intimations of a cosmic order.

The book pertinent to Kandinsky's geometric abstraction, though its content was conceived years before, was ready to be published, in the Bauhaus Books series, under the title *Point and Line to Plane (Punkt und Linie zu Fläche),* in 1926. This treatise relates to the artist's "constructive" period much as *On the Spiritual in Art* related to his Expressionist phase. Implied in the title is the genesis and extension of form from the dimensionless point to the one-dimensional line and the two-dimensional plane. As color was the principal subject of Kandinsky's earlier volume, the Bauhaus text emphasizes structure. Ideologically and stylistically, the chapters of *Point and Line to Plane* abandon the Nietzschean creed of unbridled individualism, which was reflected in the earlier *On the Spiritual,* to pursue a more purposeful analysis of formal organization.

The Dessau years thus were productive in many ways—both in the practice of art and in the pursuit of theory. In addition, the artist's wish to establish a painting class at the Bauhaus was finally granted, despite an apparent incompatibility with the institution's stated aims, thereby allowing him to work toward a closer connection between theory and practice. In this context, the publication of *Point and Line to Plane* must have been especially gratifying to the artist, although his intention to carry such work into further volumes remained unfulfilled.

Kandinsky's creative productivity during these years took place in an increasingly difficult atmosphere. The politicization of the Bauhaus, already evident in Weimar, had become more intense in Dessau, where the student body and some of the teachers leaned strongly to the left. Hannes Meyer, who succeeded Gropius as Bauhaus director, was identified with leftist politics and eventually forced out by officials increasingly susceptible to pressures from nascent Nazism. Even the succession of Mies van der Rohe, who vowed to depoliticize the Bauhaus, could not forestall the rightist attacks against an institution that in the eyes of Hitler's cohorts was tainted by "Bolshevism." After a final move to Berlin in 1932, the Bauhaus—from which some faculty members, but not Kandinsky, had already removed themselves—closed for good in August 1933.

FINAL YEARS IN PARIS

After efforts to prolong the life of the Bauhaus artificially had failed, Kandinsky, having held on beyond reasonable hope, finally followed the general exodus, eventually settling in Paris.

Living in retired fashion in the elegant suburb of Neuilly-sur-Seine, the artist was aware of the movements that in the 1930s enlivened Paris. Since, to Kandinsky, Cubist-derived, reductive tendencies were never congenial (he remained one of the very few great painters of his generation to avoid passage through Cubism altogether), it was perhaps natural that the still-active Surrealist currents would have some appeal, even though Kandinsky, now in his seventies, was too independent for direct influence. A partial infiltration of Surrealist forms is indeed observable, and rendered plausible by the artist's documented contacts with Jean Arp and Joan Miró. But neither the known facts nor the appearance of Kandinsky's canvases allows us to make too much of this. Futurist

devices, too, appear here and there, in faceted objects suggestive of motion, but these also cannot be considered of more than marginal significance.

It is rather Kandinsky's own Bauhaus abstraction that remains at his command, even if its relatively strict geometric base has become eroded through increasingly insistent admixtures of hitherto unused forms. It is as if the artist, less restrictive and wiser now, came to allow himself greater leeway in the choice of pictorial means. It may even be conjectured that he found in himself the need to anchor his art in a reality more tangible than one consisting of points, lines, and planes—and that in the search for it, a microscopic realm, penetrable with magnifying devices and accessible through scientific illustrations, offered itself as a visual resource. The scholar Vivian Endicott Barnett has documented Kandinsky's interest in such subject matter, locating pictorial sources that may have aided the artist in extending his imagery in this manner.

All in all, however, the painter's morphological development is more consistent than it appears. The heritage of late Impressionism and then the Fauve style, by which Kandinsky gained the necessary initial momentum, evolved quite logically through the gradual attenuation of forms toward the expressive abstraction that marked his decisive prewar achievements. And even if the geometric construction of the Bauhaus years appears to mark a sharp break with the forms used before, this is only because of our insufficient attention to the intervening Russian period, in which new impulses were able to resolve apparent contradictions (despite the scant pictorial production of that time). Finally, the work of the years in Paris, in the last decade of Kandinsky's life, is unthinkable without the consolidation of his abstract vocabulary at the Bauhaus. Still, in Paris a new sensibility, indeed a revised attitude toward reality itself, begins to emerge. It is evidenced by forms and images in which a slower and more deliberate rhythm makes itself felt, in contrast to the overcharged last works in Germany.

•

The formal and iconographical innovations that characterize the Paris period are conspicuous from the beginning. They can be highlighted by a comparison of *Development in Brown* (plate 35), Kandinsky's last Bauhaus painting, with *Graceful Ascent* (figure 35), the first canvas completed in his French exile. The former remains largely geometric, with carefully positioned, partly overlapping planes whose edges, like those of the incorporated circular forms, retain their sharpness. By contrast, the Paris work, while also carefully structured, combines semicircles and moon-shapes with soft outlines, suggestive of a living substance, that replace the disembodied architecture typical of the German years. As of 1934, the "amoeba"-shape, previously only barely intimated in isolated examples, moves to center stage. Gradually, it creates around itself a universe derived from microscopic fauna and flora, invisible to the naked eye. Without reducing the existing, ample color range, a pale, almost watery tonality is introduced to provide these biomorphic shapes with an appropriate environment (see figure 36).

The Parisian reorientation invigorated Kandinsky's art, giving it a pulsating, life-enhancing dynamic. Instead of evoking the celestial firmament, as a number of his Bauhaus compositions had, the slow, floating rhythms apparently refer to some aqueous universe. The new forms also seem to call for richer textures, in which sand and other substances take part in mixed techniques with an effective communicative potential of their own. An appropriate color range, at times quite daring, as in the work called *Violet-Orange* (1935), extends from monochromatic, aqueous greens and an occasional work in black and white to something approaching the motley appearance of Russian Easter eggs. Titles reflect Kandinsky's formal concerns as well as particular conditions or moods. A sense of intimacy and humor now evolves, reinforced at times by titles such as *Sweet Trifles, Touching Little Thing,* or *An Intimate Celebration.* Assimilating to the country of his residence, the artist now began assigning titles in French, much as he had used German ones during the Munich and Bauhaus years.

Compared with what it had been in Weimar and Dessau, Kandinsky's productivity in Paris slowed down. Except for 1943, the year before his death, no calendar year records more than twenty paintings, though the output of gouaches and watercolors modifies such statistics. But the implications of the slowdown are different from those of the Russian years. An enhanced concentration and deepened thoughtfulness, rather than external distraction, offer themselves as plausible explanations. Despite the slower pace, the Paris years probably witnessed the largest number of uncontested masterpieces since the "heroic" years in Munich. *Composition IX* and *Composition X* (plates 36, 38) are to Paris what *Composition VIII* (plate 30) was to Weimar—major statements cast in definitive and imposing formats. In

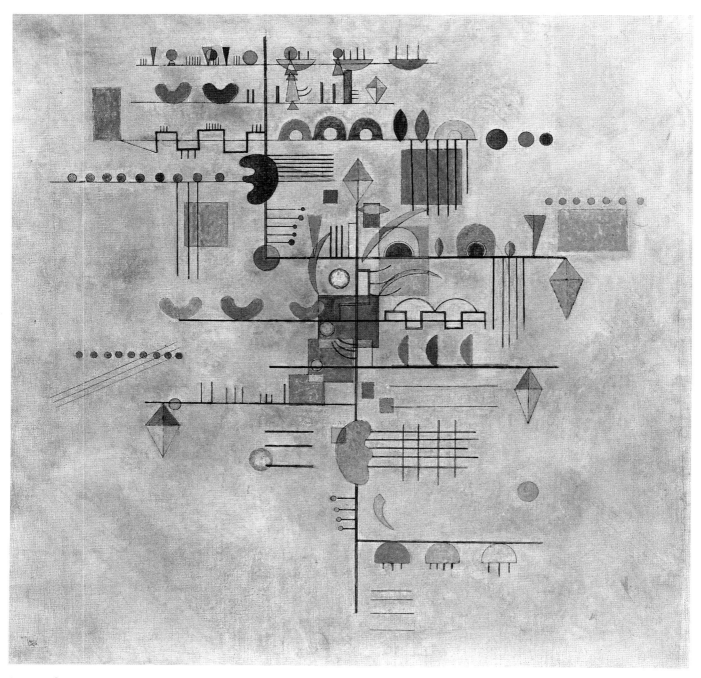

35. *Graceful Ascent*. 1934. Oil on canvas, 31½ × 31½″ (80 × 80 cm). Solomon R. Guggenheim Museum, New York

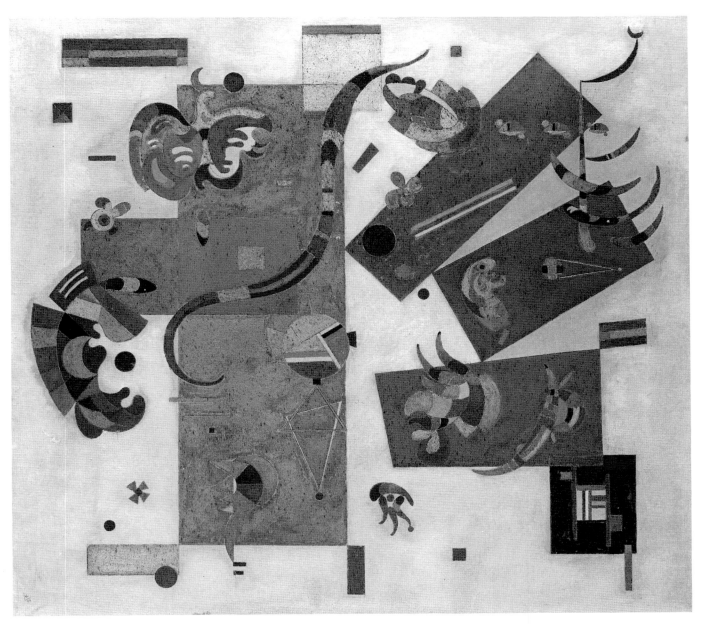

36. *Blue World*. 1934. Mixed mediums on canvas, 43¼ × 47¼″ (110 × 120 cm). Solomon R. Guggenheim Museum, New York. Gift of Solomon R. Guggenheim

the two Paris Compositions, firm, rational structure and a playful, almost Baroque countercurrent bespeak the relaxed wisdom of the artist's old age.

As the 1930s drew to an end, Kandinsky produced canvases of great scope and power in which his various approaches are seen in complementary and contrasting examples. The biomorphic intensity of a work like *Capricious Forms* (figure 37) is remarkable for the abandon and the playful delight that now set his forms free. It contrasts sharply with, for instance, *Two, Etc.* (figure 38), which may be read as a "call to order," a reminder that the accomplishments of the Bauhaus have not lost

their validity. The caution is perhaps unnecessary, since the ever prudent Kandinsky, even at his most uninhibited, in the fanciful movements of amoeba-shapes floating through aqueous hues, keeps the work structured, balanced, and altogether controlled. Titles like *Rigid and Bent* or *Reduced Contrasts* are indicative of the paradoxical tensions, as well as the resolutions, that the artist had always sought and that now assumed an ever more specific meaning; others, like *Serenity* or *Moderation,* denominating major canvases of the late 1930s, are symptomatic of the artist's retiring and yielding mood.

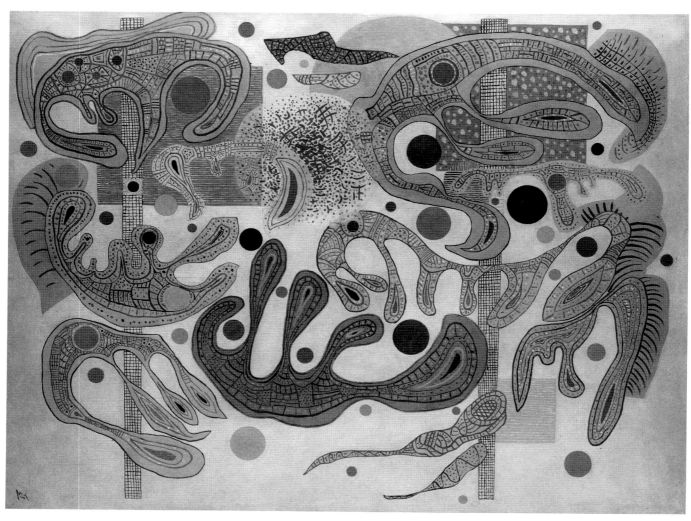

37. *Capricious Forms.* 1937. Oil on canvas, 35 × 45⅝″ (89 × 116 cm). Solomon R. Guggenheim Museum, New York

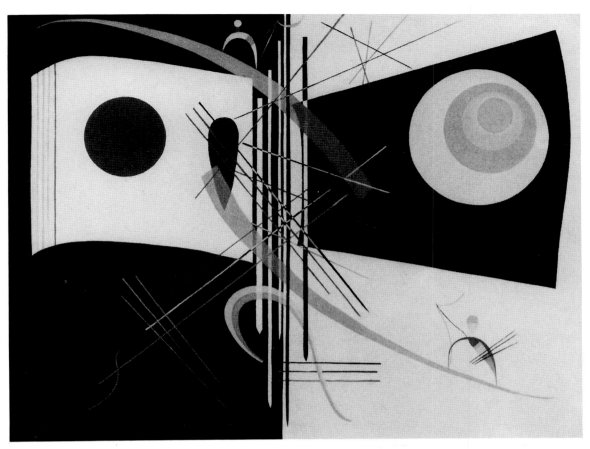

38. *Two, Etc.* 1937. Oil on canvas, 35 × 45⅝″ (89 × 116 cm). Formerly Aimé Maeght Collection, Paris

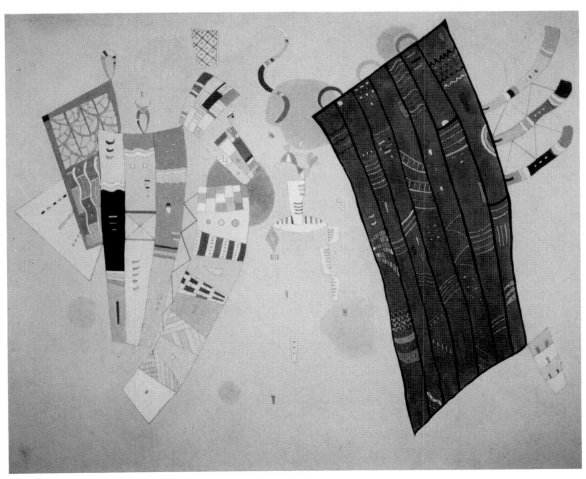

39. *Delicate Tensions.* 1942. Oil on canvas, 32 × 39⅜″ (81.3 × 100 cm). Formerly Adrien Maeght Collection, Paris

40. Nina Kandinsky, the artist's widow, in the Neuilly apartment in the 1960s.
On the left wall, Kandinsky's *Backward Glance* (1924) and *Tempered Elan* (plate 40);
on the right wall, Henri Rousseau's *The Poultry Yard*

Similar formal and verbal evocations, with subtle yet apparent modifications, carry into the early 1940s. Among the major works of the period are *Reciprocal Accord* (plate 39), with its tantalizing figurative implications, and the subtly spatial *Delicate Tensions* (figure 39), which was to be the painter's last work executed on canvas.

With the beginning of the German Occupation in 1940, life in Paris became difficult. The artist was now in his mid-seventies. In 1943–44, Kandinsky painted a valedictory group of works, a series of mostly dark oils and gouaches on cardboard, none more than fifty-eight centimeters in height or width and most of them much smaller. The works have great density, freedom from preconceived notions, and a compelling persuasiveness. Among the eight small works that he completed before his death, on December 13, 1944, and which concluded Kandinsky's creation as a painter, is *Tempered Elan* (plate 40). Here, the emblematic figure of the horseman returned for the last time.

41. Memorial plaque to Kandinsky in Odessa

COLORPLATES

1. STUDY FOR "THE SLUICE." 1901

Oil on cardboard, 12⅝ × 9⁷⁄₁₆" (32 × 24 cm)
Städtische Galerie im Lenbachhaus, Munich

Vasily Kandinsky's formation as an artist was extraordinarily slow. Although he was by his own account responsive to visual stimuli from early childhood, he passed his thirtieth birthday before enrolling in art school and did not achieve artistic independence until the early years of the twentieth century, when he was in his mid-thirties. After arriving from Moscow in 1896, he had diligently begun to explore Munich and the surrounding countryside, but without abandoning in his work the scenery of his Russian homeland. It is the latter that he recorded in such pictures as *Study for "The Sluice,"* choosing as his subject a site on the estate of his cousin and sister-in-law, Mania Abrikosov, at Achtyrka, outside Moscow.

This small oil study with its marked palette-knife strokes and its clear structure is among the artist's most accomplished early works. It was preparatory to a canvas more than twice as large and dated 1902. The canvas includes a small figure, whose bare, almost hidden outlines become visible against the dam's spillway structure. But apart from this, the larger work remains almost identical with the conception of this early version.

The dam extends through stagnant waters and reaches toward the fir trees on the other shore. A narrow color range describes an autumnal scene; the dark brown tonalities are heightened by rose hues moving across intermediary greens toward a strip of light blue sky. The artist at this stage is an acute observer of nature.

It may be assumed that Kandinsky thought highly of *The Sluice,* for, as Will Grohmann, the artist's friend and biographer, pointed out, Kandinsky had it reproduced in the first edition of his *Reminiscences* as the only representative of his numerous early landscapes.

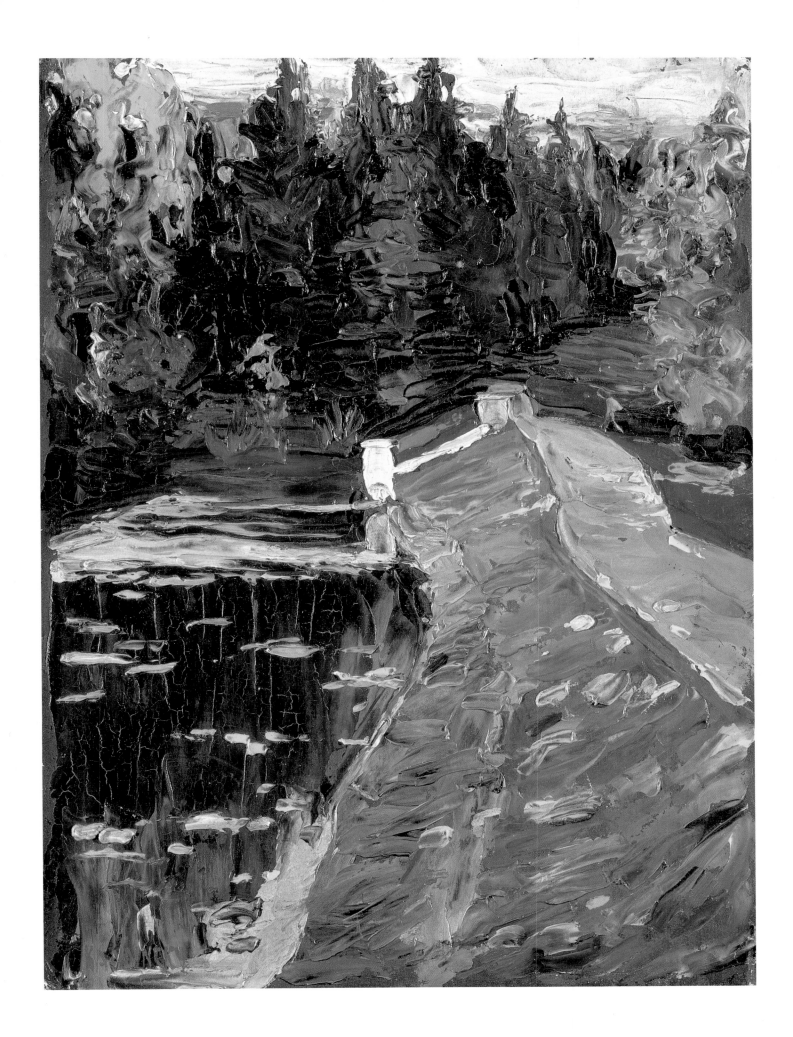

2. THE BLUE RIDER. 1903

Oil on canvas, 21⅞ × 25⅝" (55 × 65 cm)
Private collection, Switzerland

The first seven or eight years of Kandinsky's independent artistry, counting from about the turn of the century, were devoted primarily to landscape painting. The human figure at that time made only very tentative appearances. When rendered, it was mostly small, often almost unnoticeable, as in *The Sluice*. More frequently, the figure was part of a historical or mythical illustration. This small oil painting, *The Blue Rider*, therefore stands somewhat apart in its conception and treatment.

Riding from right to left the horseman is almost lost in the wide expanse of a rocky meadow defined by the clear curved line of a hill at its upper end. A row of birch trees, their white trunks enveloped by fall colors, partially bars the view toward the horizon at the right, while at the left a light blue sky and white clouds are visible. The rider wears a blue cape and casts a prominent blue shadow. His white horse speeds along in the unrealistic posture of conventional racehorse depictions, front and hind legs stretched apart and tail pointing straight back.

The title, referring to a solitary "blue rider," was apparently added after the completion of the painting. But what if this horseman is not solitary—as an indistinct, childlike outline in front of him might lead us to believe. Could Kandinsky have been thinking of Goethe's poem "The Earl-King," and its child abducted by Death, and could he have done so in disregard of its opening lines, which set the scene in "night and wind"? We cannot know.

But Kandinsky has, in any case, conjured up a tightly composed poetic vision within a color scheme of greens, blues, and reds, in that quantitative order, creating a rough surface through emphatic brushstrokes and signing "KANDINSKY" in red at the lower right.

The theme here depicted was much on Kandinsky's mind in the early years of the century. The Städtische Galerie im Lenbachhaus, Munich, owns a colored drawing and a tempera painting devoted to it. In at least two woodcuts of the same period, the single rider constitutes the central subject.

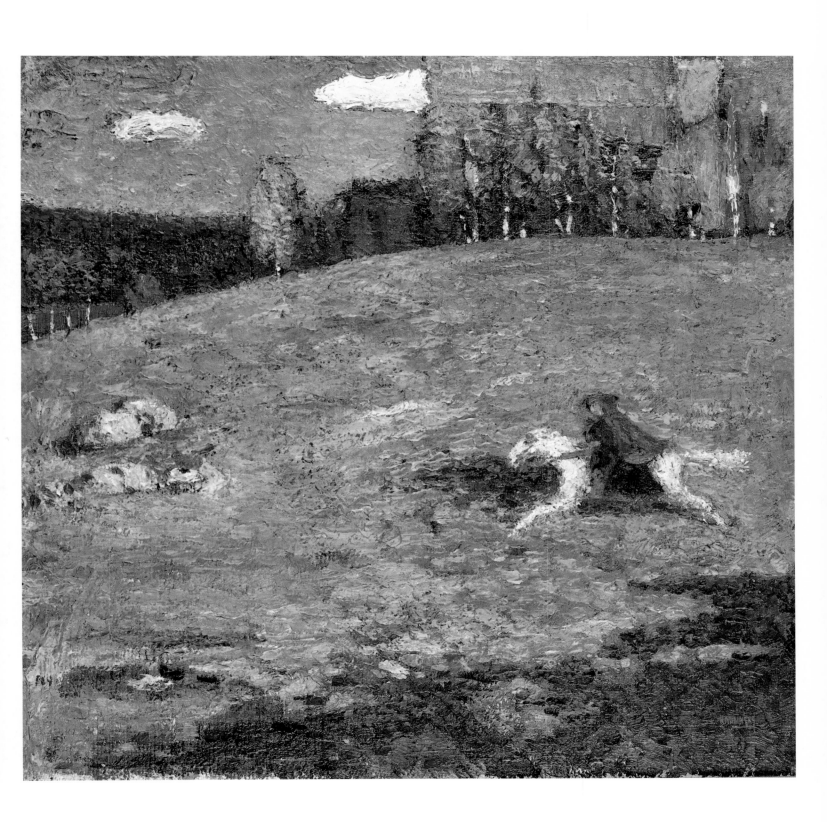

3. HOLLAND—BEACH CHAIRS. 1904

Oil on canvasboard, 9½ × 12⅞" (24 × 32.6 cm)
Städtische Galerie im Lenbachhaus, Munich

Kandinsky was a great traveler through most of his life. The first decade of the new century was the time of his somewhat belated *Wanderjahre,* the years when a young journeyman gathers impressions and broadens his outlook on his calling. The artist's first marriage, to his cousin Ania Shemiakina, remained a rather distant affair and led to a relatively painless legal separation in 1911. Even before then, Kandinsky was being accompanied on his travels by Gabriele Münter, the student with whom he fell in love in 1902 and who remained his companion throughout their subsequent stay in Bavaria. From Munich, the two traveled extensively, repeatedly visiting the Salons in Paris and exhibitions throughout Western Europe. In 1904, an excursion to the Dutch seaside produced the work here reproduced.

This small painting is one of the most attractive from Kandinsky's early period. Lighter and more spacious than most others of the time, it recalls the Divisionist works of the French Neo-Impressionist painters, whose theories interested Kandinsky. Blue, gray, and gray-green accents enliven a predominantly yellow tonality. Streaky in places and dotted in others, the free application of the paint allows the support to show through in the foreground, which, although devoid of objects, remains far from empty. Further back in the picture space, abandoned chairs stand around haphazardly, facing out to sea or toward the shore, as they form a serpentine along the receding beach. Houses are visible on a nearby, gently sloping hill; beyond it, the sea and sky melt on the horizon. A calm, sunny mood pervades the painting. In subject matter as well as in treatment, the picture remains somewhat apart from the denser and leafier works that are more common in this early Munich phase.

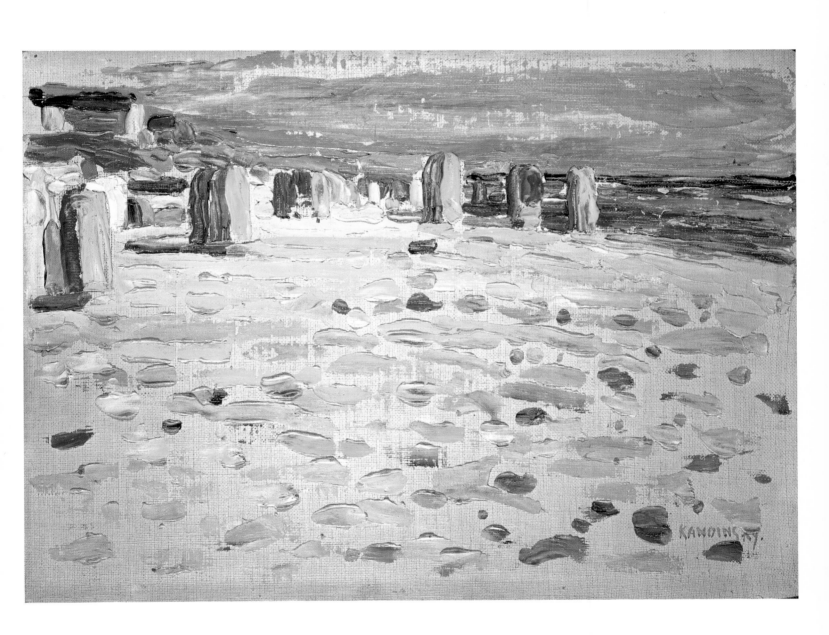

4. RIDING COUPLE. 1907

Oil on canvas, 21⅝ × 19⅞" (55 × 50.5 cm)
Städtische Galerie im Lenbachhaus, Munich

A decade after Kandinsky left his Russian homeland, nostalgic images of Moscow still returned with some frequency. Medieval legends, with their saints, knights, and noblewomen, their swords and goblets, provided the artist with subject matter for paintings, drawings, and prints. No other work in this manner quite matches the lyricism of *Riding Couple,* one of Kandinsky's most poetic illustrations to come out of Art Nouveau and Neo-Impressionist traditions.

Viewed across the river, the white, walled city, with its golden and multicolored cupolas, sparkles in the sunlight and is reflected in the stream below. Yet much of the rest of the painting is almost grisaille. Only a subdued light is allowed to penetrate the trees, leaving the riding couple in shadow. The dotted, mosaiclike technique serves Kandinsky well as he seeks a narrative idiom comparable to that of old folktales, with their universality of theme.

The subject—lovers entwined in an embrace, riding in self-forgetful bliss through slender birch trees along a riverbank—is of course unabashedly sentimental. It belongs to the world of Germanic-Slavic fairytales often illustrated in children's books. In tracing the artist's early stylistic development, the Kandinsky scholar Peg Weiss noted the existence of two parallel tendencies. Naturalism, evident in closely observed landscape paintings, competes with the more lyrical impulses that are seen most consistently in woodcuts of the same period. In this sense, *Riding Couple* ranks as a lyrical counterpart to the prevalent naturalistic landscapes. Kandinsky, in a letter to Gabriele Münter, reported on the progress of his sketch for the "quiet couple on horseback," while referring to himself as a painter-poet: "I have embodied in it much that is in my dreams: it really resembles an organ, there is much music in it." It must nevertheless be pointed out that in its thematic explicitness, narrative intent, and illusionist rendering, *Riding Couple* contains much of what the artist would later reject.

Thematically related works include two earlier prints devoted to romantic farewells and a subsequent woodcut titled *Rocks.*

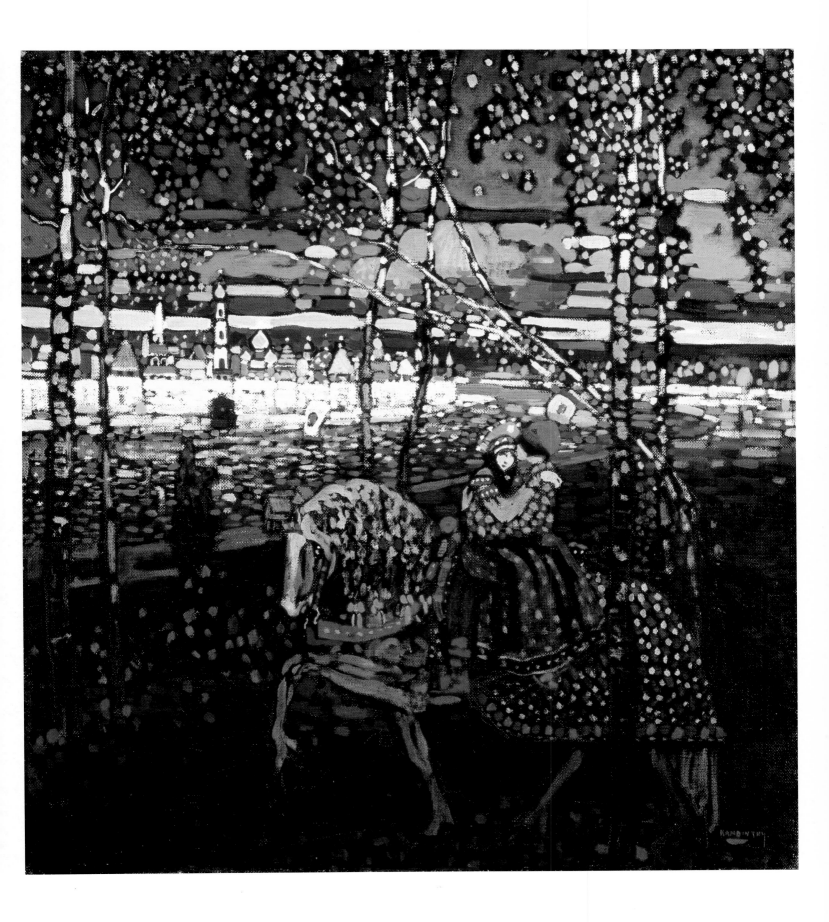

5. THE BLUE MOUNTAIN. 1908–9

Oil on canvas, 41¾ × 38″ (106 × 96.6 cm)
Solomon R. Guggenheim Museum, New York.
Gift of Solomon R. Guggenheim

Kandinsky and Gabriele Münter first visited the small Bavarian village of Murnau, near Munich, together in 1908. Painted at about that time, *The Blue Mountain* heralds a new phase; it introduces a style of painting far removed from the descriptive essays of earlier years. The work appears to reflect an awareness of Fauvism, a style that Kandinsky encountered during his trips to Paris. The artist, now forty-two years old, was at the threshold of accomplishments that would establish him as one of the most original and radical innovators of his time. *The Blue Mountain* constitutes a preliminary phase in Kandinsky's cautious yet determined effort to free painting from its dependence on the forms of nature.

The effective integration of its tightly defined planes endows *The Blue Mountain* with an intriguing formal complexity. The three horsemen, juxtaposed against the mountain, are in front. Two outsized trees, placed in the middle ground and leaning toward each other, infringe on the shrinking patch of sky that constitutes the background of the painting. The color scheme relies on primaries, with green as an understated fourth hue.

The meaning of this scene is not as easily established as that of the spellbound lovers in *Riding Couple* (plate 4), for Kandinsky is no longer pursuing narrative objectives. The painting, however, remains figurative, if somewhat ambiguously so, with its attenuations and arbitrarily applied colors. Although various interpretations, some of biblical origin, have been proposed, it is the shapes and colors applied to the canvas that now assert themselves separately from the insinuated theme. The lyrical strain of *Riding Couple* is abandoned in favor of a more dramatic mode, leaving behind the naturalism of earlier works.

Two horsemen in an earlier woodcut, titled *Clouds,* prefigure the movements of the riders in *The Blue Mountain*.

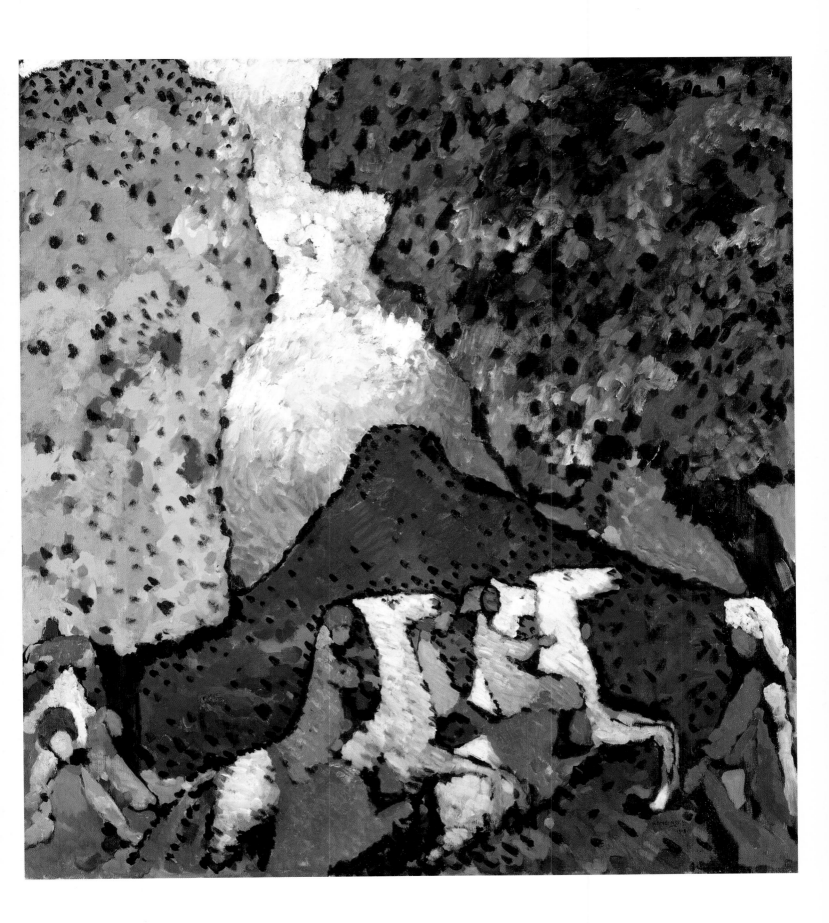

6. CRINOLINES. 1909

Oil on canvas, 37⅞ × 50⅝" (96.3 × 128.5 cm)
The State Tretiakov Gallery, Moscow

Kandinsky employed the crinoline-motif for the first time in an oil and tempera canvas titled *Bright Air* of 1901. In 1903, the modish costume appears repeatedly in color engravings, in black-and-white woodcuts, and in a tempera on black paper, now in the Städtische Galerie im Lenbachhaus, Munich. Kandinsky then returned to the theme in the work here reproduced and, once again, later the same year. A more abstract reinterpretation, with only a vestigial crinoline theme, recurs as late as 1911.

Ladies of high society, wearing wigs and holding fans and bouquets, are politely conversing in a formal garden, where nature merely lurks in the background beyond the manmade structures. The world of society had always held some fascination for Kandinsky, who would return to fashionable genre scenes as long as figurative content remained part of his vocabulary. But his *Crinolines* also bespeaks a purely structural interest in the calculated interplay of coloristic effects, which the artist was formulating at the time for publication in his first theoretical treatise, *On the Spiritual in Art*.

The firmly constructed *Crinolines* builds on a succession of bands, arranged as receding planes. Such deliberate, even pedantic structuring is eased by an engaging color scheme in which neutral greens dominate while yellow, red, pink, and orange hues combine to give the work its joyous mood. A vibrant, dotted surface further enlivens the scene.

By comparison with the rigidly defined planes of the present version, the somewhat later *Group of Crinolines* follows a passionate, serpentine pattern; figures in various positions and postures, as well as the freedom of the brushwork, endow that painting with almost Baroque attributes. Finally, in the thematically related canvas *Pastorale,* the crinoline theme needs to be extracted from an interplay of planes, colors, and shapes within which it is about to dissolve.

By 1909, the year the Tretiakov Gallery's *Crinolines* was completed, Kandinsky had moved forward on several fronts. The production of ambitious paintings was accompanied by the formulation of fundamental theories of art and the publication of critical articles in Germany as well as in Russia. Elected to the presidency of the Munich New Artists' Association, Kandinsky took polemical positions in defense of abstract art and participated actively in the organization of exhibitions. *Crinolines* was among the paintings included in the first exhibition mounted by the New Artists' Association.

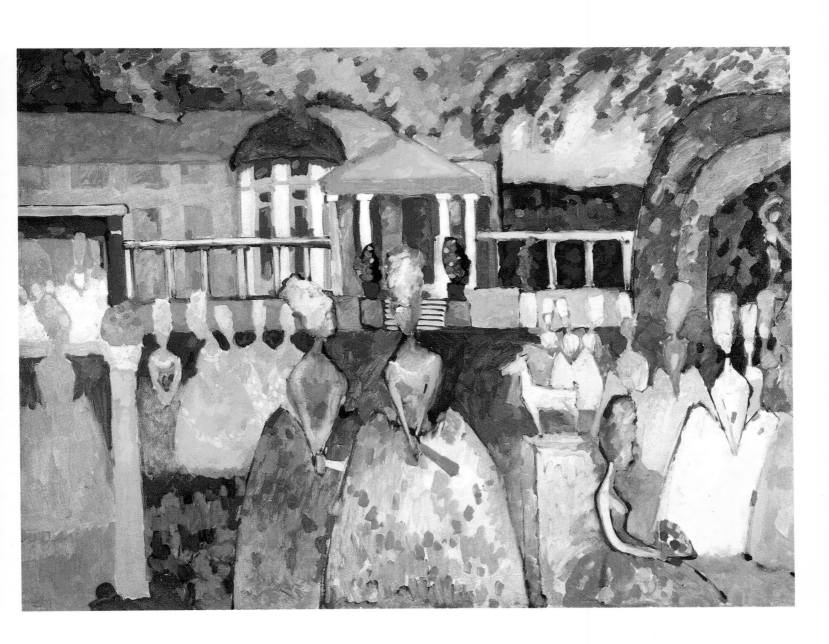

7. PICTURE WITH AN ARCHER. 1909

Oil on canvas, 69 × 57" (175.3 × 144.8 cm)
The Museum of Modern Art, New York.
Gift and Bequest of Mrs. Bertram Smith

This intensely expressive canvas demonstrates the emotional range of Kandinsky's art. Completed shortly after *Crinolines* (plate 6), *Picture with an Archer* evokes an altogether different response.

Entering at top speed at the lower right of this large vertical oil painting, the mounted archer is turning backward in the saddle of his horse. We see him aiming his bow. Is the arrow pointed at a pursuing enemy? A parting shot, perhaps? Kandinsky does not tell us. Nor does he explain the rider's relationship to the quiet procession that appears to be leaving the cloister in the background. But he lavishes his somber palette on a monumentalized nature, in which, as in the earlier *Blue Mountain* (plate 5), planes abut, overlap, merge, and separate again. The natural world seems to strive upward into a turbulent sky, defined by a dominant blue-green color chord with earthen rose as counterpoint. Yet if there is symbolism in, for example, the juxtaposition of the huge trunk with the slender young tree that leans inward like a parenthesis, it is proposed so tentatively as to be there or not, at the viewer's discretion.

The horse-and-rider image is not only a recurring one but assumes in Kandinsky's oeuvre a central, often self-referential significance. The first oil painting with this subject is *The Blue Rider* of 1903 (plate 2). The theme is repeatedly linked to the legendary Saint George, the artist's favorite saint, and reappears frequently in various transformations. It would make its final emblematic appearance in *Tempered Elan* (plate 40), the artist's last finished painting, made in the year of his death.

A woodcut of an archer, based on a very small, schematic pencil drawing with color indications, was executed in the same year as the painting here reproduced, thus allowing a comparison between Kandinsky's practice in the two mediums. Indeed, the artist's application of graphic techniques to oil painting in his development toward abstraction has been cited as one of the reasons for the flattened perspective of works like *Picture with an Archer*.

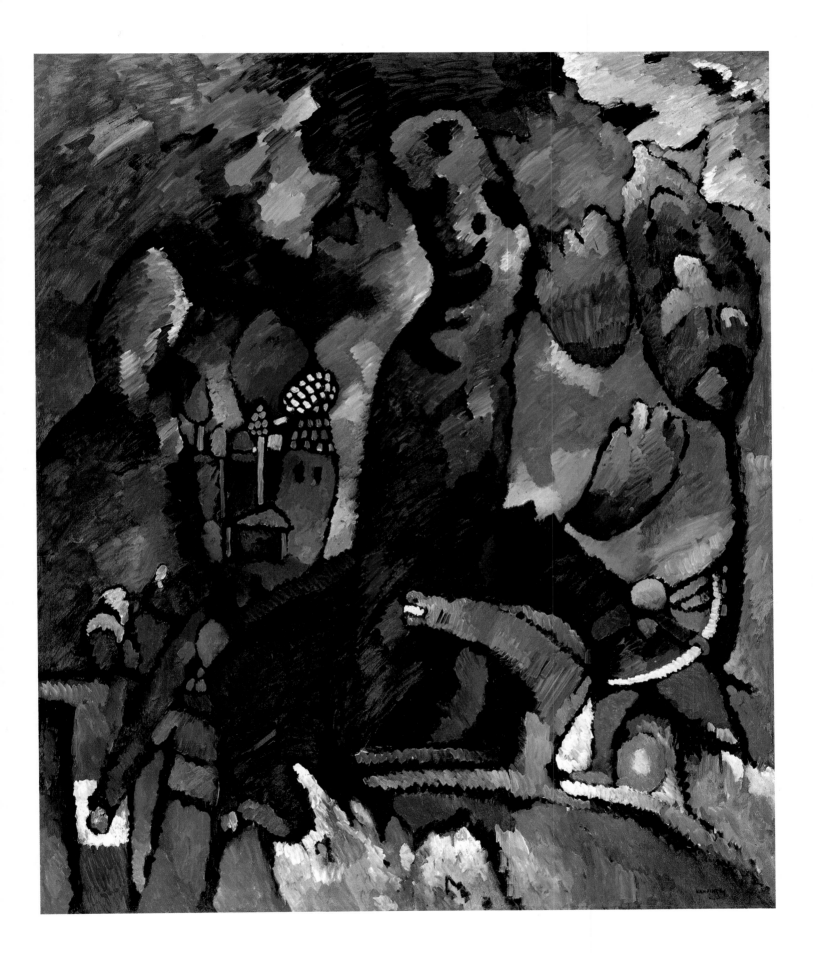

8. SKETCH FOR "COMPOSITION II." 1910

Oil on canvas, 38⅛ × 51⅜" (97.5 × 131 cm)
Solomon R. Guggenheim Museum, New York

As the first decade of the century drew to an end, Kandinsky came fully into his own. His production as well as his authority in the art world increased markedly. The artist's creative powers and self-confidence were evidenced by his decision to create major works whose importance he emphasized by setting them apart with the series designation Compositions. These he defined as works in which "the expressions forming within me (very, very slowly) are examined and elaborated by myself on the basis of initial sketches, extensively and almost pedantically." And he added: "In this, reason, consciousness, the deliberate and the purposeful, play a preponderant role. However, what is decisive is not calculation but feeling." There were only ten such numbered paintings throughout his career, of which seven remain after the disappearance of *Composition I, Composition II,* and *Composition III.* Fortunately, the final study for *Composition II,* the oil sketch reproduced here as plate 8, is known to be close to the lost painting (although half its size). As is the case with many other major works, preparatory as well as subsequently executed examples in other mediums play a revealing role. Here, a watercolor painted on cardboard, now in the Städtische Galerie im Lenbachhaus, Munich, as well as two woodcuts, throw light on the meaning of the final version.

The thematic content of *Sketch for "Composition II"* is nothing less than baffling and has kept scholars guessing as to its precise meaning. Analysis has been further hampered by the artist's insistence that the painting simply had no theme, but merely reflected a feverish dream vision, carefully recomposed. Even so, the viewer cannot miss two centrally placed riders on white and blue horses, though it is unclear whether they are in combat or simply galloping headlong. Indistinct personages, on land or in or near water, stand, walk, run, or lie, float or sink, all toward no visible purpose. All this commotion is set in a landscape in which waves, clouds, trees, grass, rocks, and mountain peaks envelop and partly merge with the human element. As has already been noted in *Picture with an Archer* (plate 7), the different actions within a single work are not necessarily coordinated. This led Hans Konrad Roethel, the eminent Kandinsky scholar, to conclude that *Composition II* corresponds to a play in three acts—which are performed simultaneously. In analyzing the painting, Will Grohmann pointed out that in it, space has assumed a different meaning: "The painting is constructed upward from below, avoids almost entirely the effects of distance or depth, but carmine red occupies a different plane than white, and blue another than green." In *Composition II,* Kandinsky achieved, largely through formal means such as these, an equilibrium—between the turbulence suggestive of a deluge and the joyousness of a garden of love.

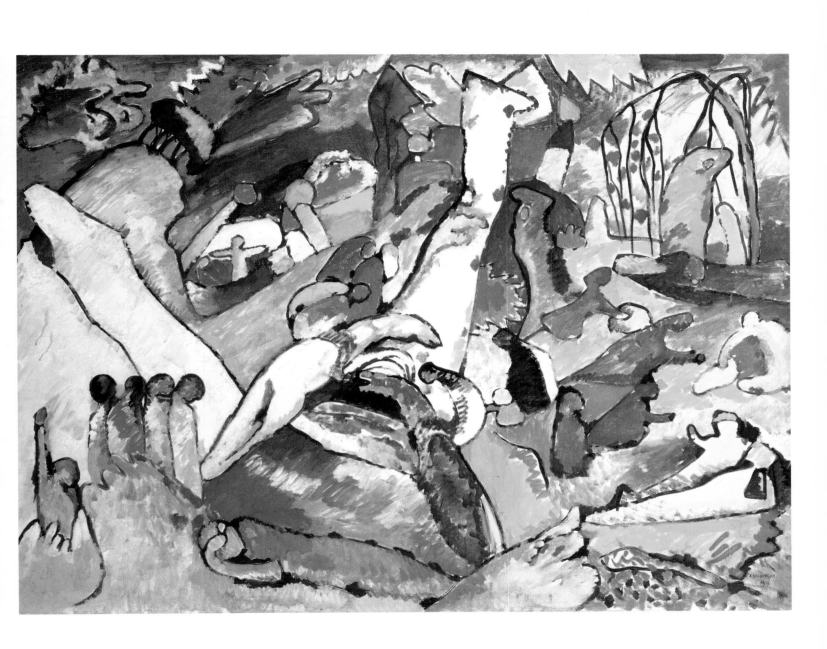

9. BOAT TRIP. 1910

Oil on canvas, 38⅜ × 41⅜" (98 × 105 cm)
The State Tretiakov Gallery, Moscow

Kandinsky's paintings are held in significant numbers by a relatively few museum collections. The Städtische Galerie im Lenbachhaus, Munich; the Solomon R. Guggenheim Museum, New York; the Musée National d'Art Moderne, Centre Georges Pompidou, Paris; and the state museums in Moscow and Saint Petersburg account for the bulk of the artist's most important canvases. *Boat Trip* (alternately referred to by the artist as *Lake*), now in the State Tretiakov Gallery, was, according to Nina Kandinsky, the artist's widow, left behind under some duress at the end of 1921, the year of Kandinsky's final departure from Russia.

This dark oil painting is striking in its tonal and coloristic contrasts, its clear formal organization, and its mysterious action. Three boats, each manned by three blue oarsmen and one red pilot, move past an indeterminate structure toward a nearby ship. The strenuous undertaking takes place in dark waters under a partially obscured orb that shines through a mighty rainbow. There is no clue as to the significance of such vehement striving, which is rendered in emphatic brushstrokes that add further excitement to this scene charged with mystery.

It is evident from such works that Kandinsky's road to abstraction was far from direct. The radical features of *Composition II* (see plate 8) are muted here, as they had been in *Crinolines* (plate 6), compared with the harsher dissonances in some preceding examples. While much preoccupied with the issue of abstraction on the theoretical level, Kandinsky seemed in no great hurry to realize its full potential in his painted works. Indeed, *Boat Trip* assumes an atypical position in Kandinsky's oeuvre by seeming to hark back to the Romantic imagery of his teacher Franz von Stuck or, as Grohmann pointed out, even beyond him to Arnold Boecklin, the nineteenth-century Swiss-born painter of the famous *Isle of the Dead*. A related color woodcut, much more agitated and abstract, illustrates the volume of Kandinsky's poems titled *Sounds (Klänge)*.

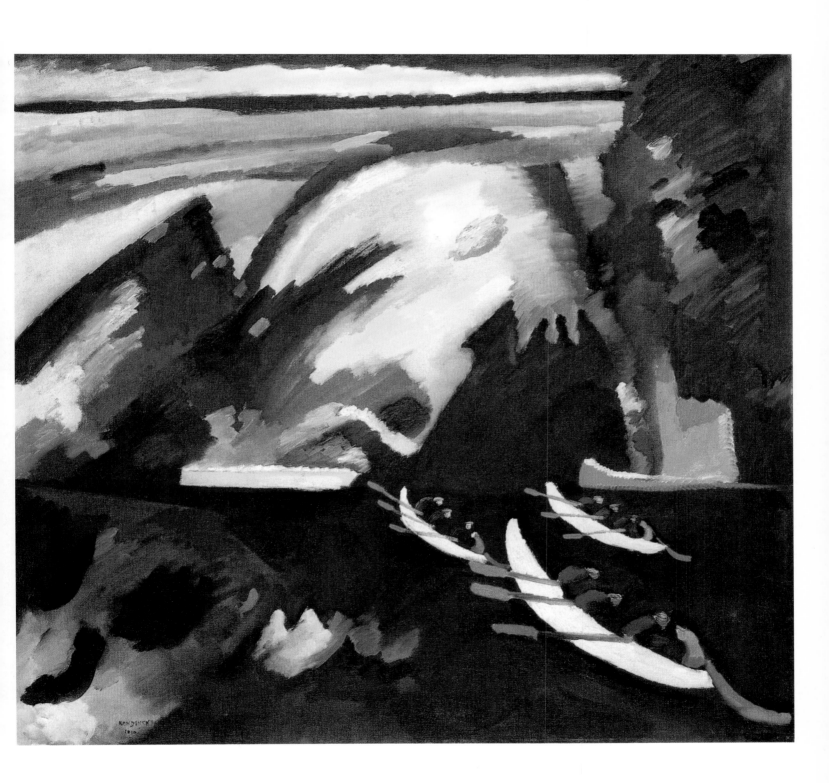

10. THE COW. 1910

Oil on canvas, 37⅝ × 41⅜" (95.5 × 105 cm)
Städtische Galerie im Lenbachhaus, Munich

The animal designated by the title is simultaneously idea, image, and plastic form. The title is of consequence not only because it names the principal subject of the painting, but also because the image confers mood and meaning on the work as a whole. This holds true even though the white cow-shape is painted so delicately as almost to escape notice, at least before the beholding eye adjusts to the overlapping images that constitute the composition and learns to distinguish between the individual objects, natural as well as manmade, in their close proximity to one another. Then, the grazing animals to the right are reduced to small replicas of the great primal incarnation—which seems to lean into the mountain, while the mountain in turn presses into the more distant hills and sky.

In contrast to the many dynamic paintings of the same period, *The Cow* is appropriately placid, evoking an airy, deeply satisfying orderliness. This sense is derived from the calmly overlapping planes, but also from an application of color that allows contrasting tonalities to occupy large areas, thus avoiding rapidly changing visual sensations. Blue and green hues, discretely applied, provide subtle enrichments to the dominating white.

Despite a subject matter that will not be denied, this engaging canvas moves toward the realization of a non-objective vision. The dominant image remains only tenuously poised on the surface, like a mere shadow. It has ceded its role as the primary reality carrier.

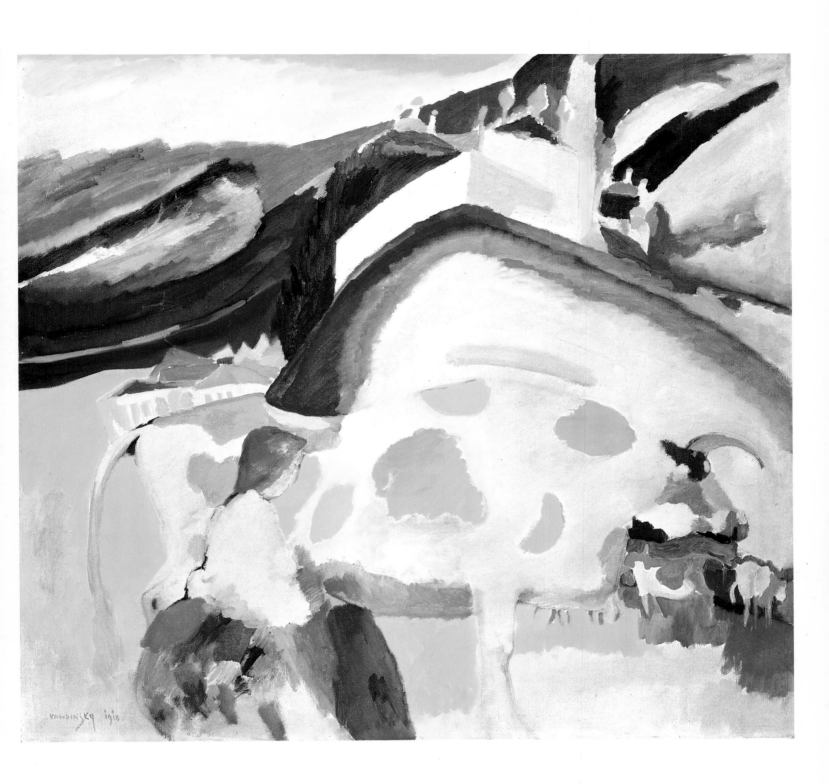

11. ROMANTIC LANDSCAPE. 1911

Oil on canvas, 37⅛ × 50" (94.3 × 129 cm)
Städtische Galerie im Lenbachhaus, Munich

The year 1911 was a significant one in the life of the artist. Besides producing some of the most impressive works of his career, Kandinsky laid claim to creating his first wholly non-objective painting. The vestigially figurative work illustrated here, however, may serve as evidence that his stylistic progression was by no means consistent. In his treatise *On the Spiritual in Art,* Kandinsky envisaged a form of visual expression capable of projecting meaning without reference to recognizable objects. Yet his own painting proceeded toward such a consummation only haltingly and with many a detour. In the first edition of *On the Spiritual,* which appeared in December 1911, the author asserted that painting, in its aspiration to approximate the condition of music, was not yet able to do so without relying on external imagery. Works like *Romantic Landscape* prove the point by continuing to derive support for their essentially abstract mode through thematically parallel motifs.

Here there are three horsemen again, as in *The Blue Mountain* (plate 5), but this time they sweep down a white, sunlit field. The work is constructed with nearly parallel linear accents, suggestive of roads, in a landscape punctuated by trees and rocks. The deep red sun over the hill adds a conspicuously "Romantic" touch. Throughout the painting, multicolored brush dots indicate a spontaneous execution, reinforcing an underlying mood of breathless speed consonant with the overt theme.

The horse-and-rider motif, never far from the artist's thoughts, was now more than ever on Kandinsky's mind as he envisaged, in collaboration with his young artist friend Franz Marc, the publication of an "almanac" that was to bear the title *The Blue Rider (Der blaue Reiter). Romantic Landscape,* though much further developed, recalls Kandinsky's earliest painting of a single speeding horseman, *The Blue Rider* (plate 2), completed almost a decade before.

Kandinsky kept reasonably accurate written records of his production in the form of what is called his Handlist. These make it possible to distinguish between the titles that were assigned by the artist, as is here the case, and others that were not. For Kandinsky, the term "Romantic" came to acquire special significance, as he wrote many years later to Will Grohmann, proposing a new meaning for "Romantic" that would set it clearly apart from any notion of sentimentality. In this context, Kandinsky recalled *Romantic Landscape* as a work "that had nothing to do with the early Romantic."

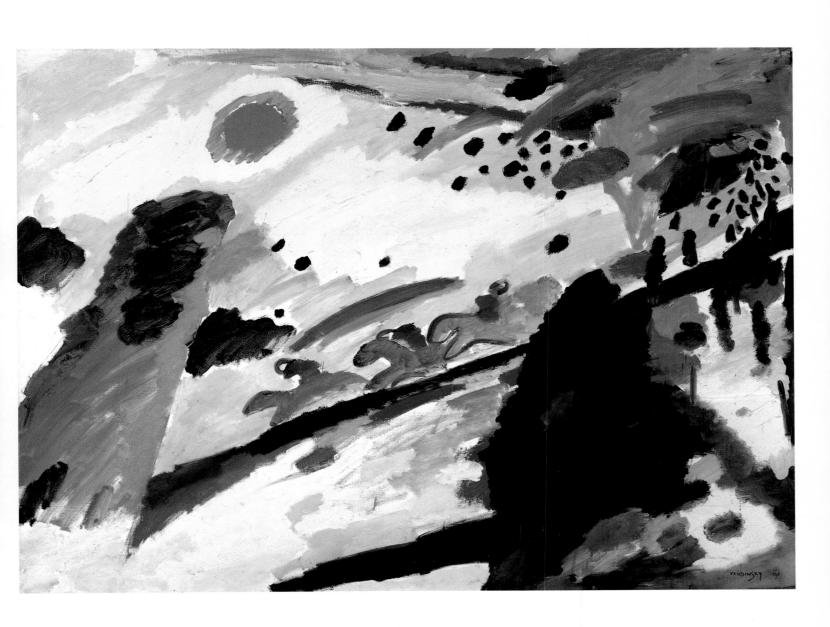

12. IMPRESSION III (CONCERT). 1911

Oil on canvas 30½ × 39⅜" (77.5 × 100 cm)
Städtische Galerie im Lenbachhaus, Munich

Kandinsky identified three generic categories among his paintings—the Impressions, the Improvisations, and the Compositions—and executed numerous works in each group. Although not easily distinguished from the works called Improvisations, Kandinsky's Impressions signified to the artist a closer relationship between observation and rendition. He spoke of direct impression as "derived from 'external nature' that is expressed in a form combining draftsmanship and painting." His six numbered canvases designated as Impressions were all executed in 1911.

Music, that great teacher of humankind, was ever present in Kandinsky's life. As a young cellist and amateur chamber musician, he learned the medium from within and retained an active interest later in life. Besides the classics, Kandinsky concerned himself with the creations of the avant-garde, paying particular attention to Arnold Schoenberg's so-called "atonal" compositions, which he viewed as somewhat parallel to his own aspirations as a painter. *On the Spiritual in Art* abounds with musical references, and his discussion of color perception is often accompanied by timbral, melodic, and harmonic analogies. Yet Kandinsky disagreed with the Wagnerian notion of the *Gesamtkunstwerk*—a single, all-embracing art form—and instead saw the visual, tonal, and verbal mediums as being in complementary relationships with each other, each preserving its separate identity and function.

According to the artist's Handlist, *Impression III (Concert)* was painted on January 3, 1911, two days after Kandinsky attended a New Year's concert in Munich with music by Schoenberg. The largely abstract composition of the painting could be viewed as inspired by atonal music, but extant preparatory sketches reveal a much more direct relationship to the incident of the performance itself.

The painting is divided into a densely populated left side and a relatively empty right. As in *Romantic Landscape* (plate 11), the composition is conceived diagonally, but the reliance on large, undivided color areas as well as the presence of two nearly vertical pillars bestow on the work a measure of stability.

Although the large black area is identifiable through the sketches as the lid of a grand piano, at the same time it also reminds us of the artist's identification of black with negative attributes. In Kandinsky's essay "On the Question of Form," black, in contrast to white, is seen as "the negative, the destructive . . . the evil . . . the black death-dispensing hand."

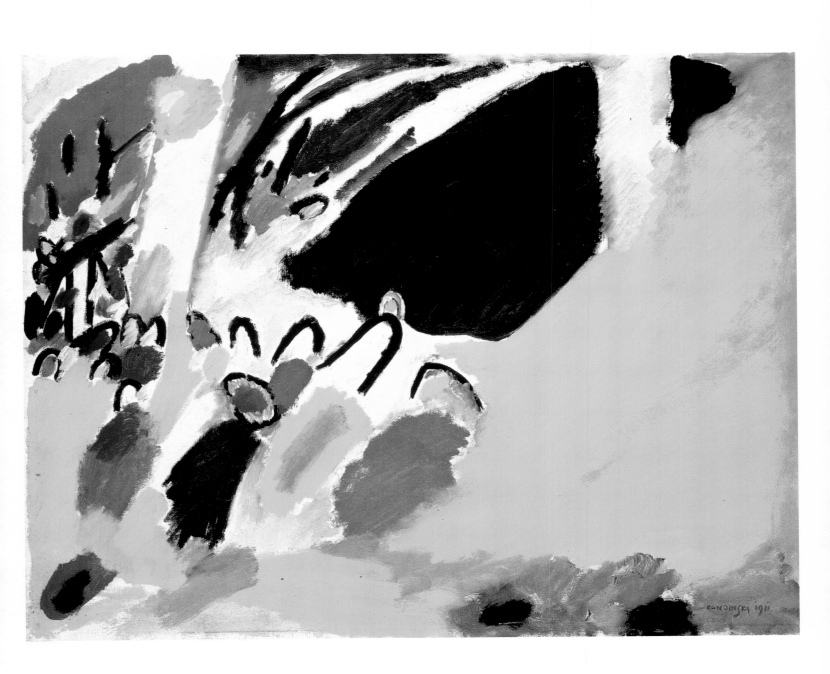

13. LYRICAL. 1911

Oil on canvas, 37 × 51¼" (94 × 130 cm)
Museum Boymans–van Beuningen, Rotterdam

Despite his stated unwillingness to burden his paintings with descriptive titles, Kandinsky, according to Will Grohmann, used the working title "Jockey" for this one, which is among his most striking canvases. Its Handlist title, however, is the German word *Lyrisches*.

The working title was of course apt, since the horse-and-rider theme is forcefully projected within a spare, essentially abstract concept. Indeed, it would be difficult to point to a Kandinsky painting in which so much has been expressed with means so reduced. The horse is indicated with a few schematic yet flowing lines, while the jockey's typical racing posture is conveyed with little more than two simple curves. The flat, posterlike conception owes much to the print medium, as the artist's color woodcut of the same composition suggests.

The familiar horse-and-rider theme here appears in a context very different from *The Blue Rider* (plate 2), *Picture with an Archer* (plate 7), or *Saint George II* (plate 14). The mythical overtones that characterize those works are less significant here, and instead, the position of the rider invites comparison with Kandinsky's works devoted to rowing, and particularly to the position of the pilots, both in the early *Boat Trip* (plate 9) and in *Improvisation 26* (plate 17). Yet symbolic interpretations of the rider theme in *Lyrical,* some traceable to the artist, are not difficult to find. Rider and horse in the respective roles of guiding reason and subordinated emotions, or the horseman as the artist in control of his art, are perhaps rather obvious allegories that add less to the painting's distinction than the graphic potency of the imagery itself. Nonetheless, it should be noted that the canvas was completed a few months before Kandinsky and Franz Marc devised their plan for the Blue Rider project, and to some extent *Lyrical* therefore reflects Kandinsky's current thoughts.

Executed in the same year and possessing the same reductive concision as *Lyrical* is a watercolor now in the Städtische Galerie im Lenbachhaus, Munich, titled *With Three Riders*. The color woodcut mentioned earlier, also of this same year, projects the graphic thrust inherent in the painting with equal force, despite the woodcut's smaller size.

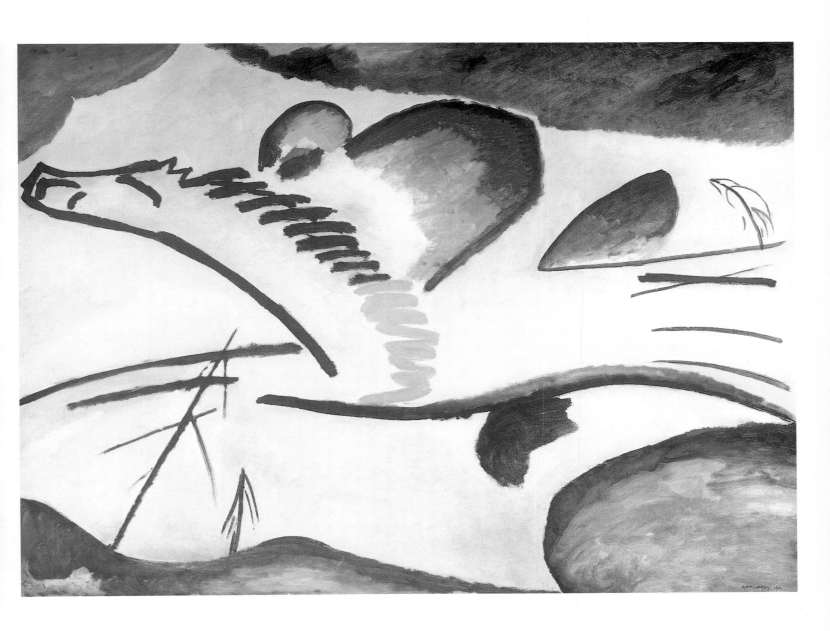

14. SAINT GEORGE II. 1911

Oil on canvas, 42⅛ × 37⅜" (107 × 95 cm)
The State Russian Museum, Saint Petersburg

The knightly figure of Saint George the dragon slayer captivated Kandinsky's imagi-
nation to such an extent that it is widely seen as an emblem of his self-image. The
artist depicted the victorious Saint George in three oil paintings as well as in works
in tempera and in watercolor, in prints, and in paintings on glass that were based on
the practices of Bavarian folk art (see figure 16 in the introductory essay, page 21). A
highly stylized woodcut of the saint is familiar as Kandinsky's cover design for *The Blue
Rider Almanac,* edited by Kandinsky and Franz Marc (see figure 19, page 23).

The present painting, *Saint George II,* presents us with an intriguing game of elu-
sive images. It would appear that the rider is thrusting the tip of his lance into the
bleeding dragon while moving away from the defeated foe. The horse, whose red
tongue echoes the visible bloodstains, turns his head around, as if to view the out-
come of the battle. A mysterious figure precedes the saint, who rides through a hilly
landscape.

Reading a work such as *Saint George II* in representational terms is no longer
mandatory, but at the same time, omitting the thematic content would certainly fail
to reveal the painting's full range of meaning. The strong impact of the work is due
in part to the successful fusion of representational and abstract elements. For exam-
ple, Kandinsky's insistence on the importance of the associative power of color, such
as the evocation of blood through red, is convincingly demonstrated here.

In this work, Kandinsky also delimits the upper left corner and similarly defines
the lower left, making use of a device here and in many other paintings that has as its
apparent purpose the "framing" of the action as if it were taking place on a stage. A
deliberate artificiality, a separation between actor and audience, is implied in such
recurring devices.

With its hard edges rendering a tight composition, *Saint George II* comes as close
to Cubism as any work by the Russian painter. But it is worth stressing in this con-
text that Kandinsky was one of the very few major artists of his generation to remain
consistently outside the orbit of that style. Because it retained its ties to the depicted
object, Cubism in Kandinsky's view stopped short of its full potential and therefore
ultimately held little interest for him.

74

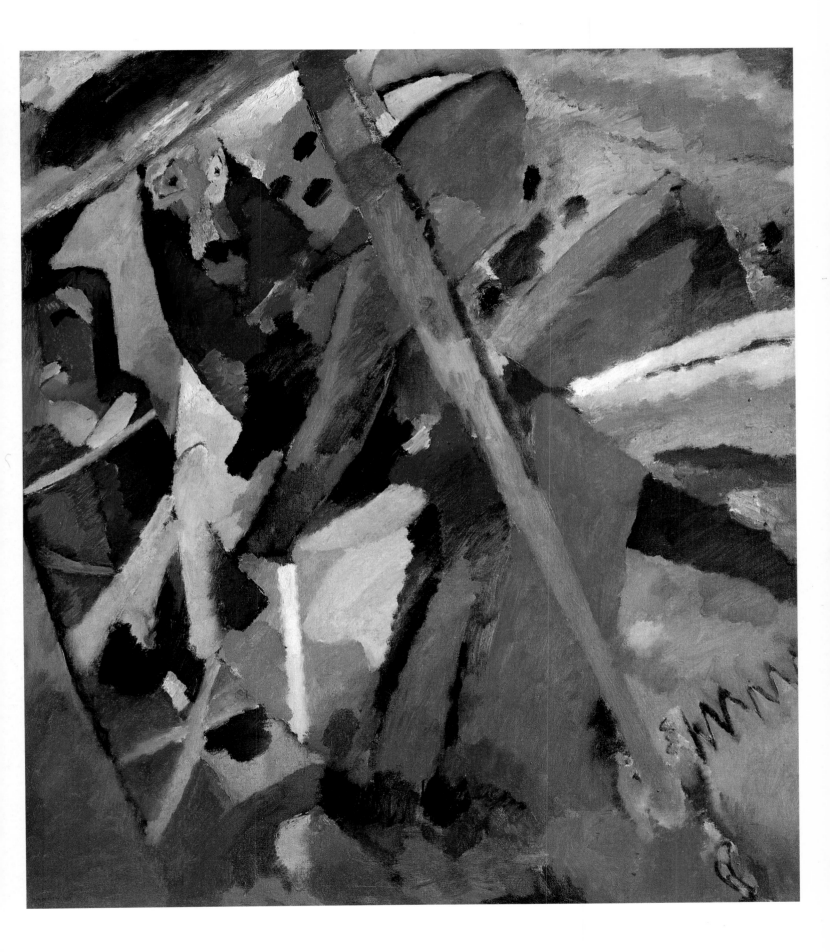

15. COMPOSITION IV. 1911

Oil on canvas, 62¾ × 98⅝" (159.5 × 250.5 cm)
Kunstsammlung Nordrhein-Westfalen, Düsseldorf

Kandinsky's first three Compositions—his designation for the works to which he attributed culminating significance—were all lost in World War II. *Composition IV* therefore is the earliest among the seven surviving Compositions, each of which constitutes a milestone in the development of Kandinsky's art. It is also one of his largest, most radiant creations. He completed the canvas in 1911, a year of prolific production that yielded a number of major masterpieces.

The painting was developed from two preparatory drawings, and it is related as well to two watercolors (only one of them fully executed) and a woodcut. There also is an earlier canvas fragment related to the painting's upper area. Such a wealth of relevant examples is an indication of the pains the artist took in approaching his Compositions.

The painting opens up, fanlike, from a center defined by a pair of parallel vertical lines. It is notable for the way that arbitrary color coexists with a firm linear structure. Vestiges of natural forms melt with pure painterly passages as if to stress the separateness as well as the ultimate congruence of these two realms.

A published interpretation of the work written by the artist himself leaves no doubt as to his priorities concerning the two aspects. Where resemblances to the objective world might lead the viewer to make specific identifications, Kandinsky's own interpretation emphasizes purely compositional objectives instead, and the means through which these are realized. Thus, even without the aid of more explicit sketches or the artist's own subtitle, *Battle,* the searching eye cannot miss certain natural forms familiar from earlier paintings: the central mountain, recalling among others the earlier *Blue Mountain* (plate 5); reminiscences of *Sketch for "Composition II"* (plate 8), with its criss-cross horse-shapes and, at the lower right, its pair of recumbent figures; or echoes of the women in *Crinolines* (plate 6), embedded in the mountain. Gigantic ascending figures, a rainbow, a celestial constellation, and an agitated sky are also rewarding finds for the beholder. Kandinsky remains discreet, however, and discourages any such obvious linkage to natural forms, even though he cannot of course plausibly deny them. Among the elements that he stresses instead are mass and weight, the contrast and confluence of forms, the existence of compositional centers, and the dissolution of the object in an autonomous realm of forms.

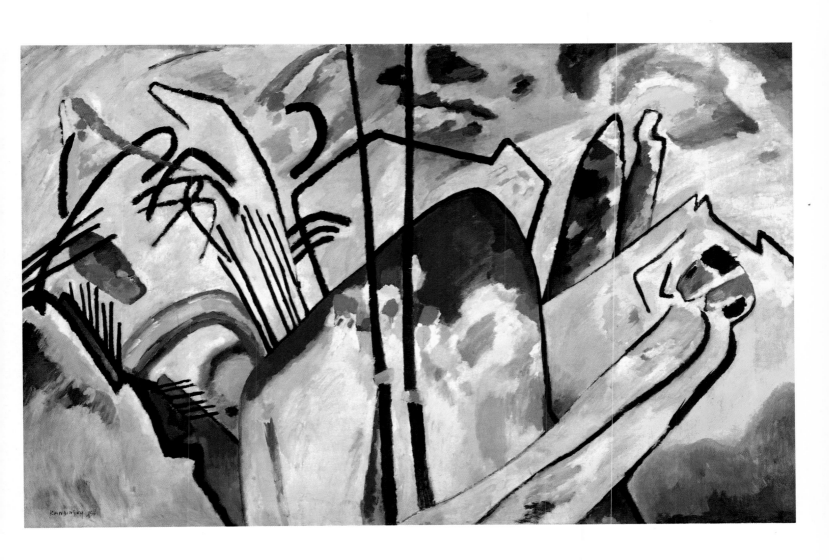

16. COMPOSITION V. 1911

Oil on canvas, 74¾ × 108¼" (190 × 275 cm)
Private collection

Iconographically, *Composition V* recalls various previously utilized motifs. The oars of the rowing theme can be found near the left edge of the canvas facing elements from *The Last Judgment* on the right, while the often recurring mountain city—which develops from *Glass Painting with Sun* (see figure 15, page 21) through an Improvisation to take final shape in the canvas *Small Pleasures* of 1913—is echoed at the top center. But the principal sensation derived from this Composition is of an abstracted eroticism, reflected in remote linear and planar approximations of the feminine anatomy, and in the pale skin color, emanating a tenderly rose and bluish aura. A contrapuntal movement of black lines interacts with these pastel hues; notably, an aggressively prominent U-shape appears amid the insinuated nudity, issuing from hidden sources and widening like a moving river. It dominates a Composition that overflows with hidden contents.

Kandinsky often found it necessary to concentrate the interaction of his forms within a defined area of the canvas. He thus set the stage, as it were, to assure the full dramatic impact of the encounters between lines, colors, textures, and planes. The patterns of *Composition V,* however, fill every inch of the painting, giving the impression of having no limits other than those prescribed by the actual measurements of the canvas. Nevertheless, a discernible rhythm, not unlike one that will again be observed in *Improvisation 34* (plate 22), leads the eye diagonally, from upper left to lower right, through lessening color intensities in which deep greens, intense reds, and darker earthen tonalities decelerate toward pastel shades, primarily in beige and blue. The conspicuous black line thus embraces dramatic as well as lyrical passages while defining their interplay in shallow depth.

This large canvas became a *cause célèbre* when it was rejected from a juried exhibition organized by the Munich New Artists' Association, thereby forcing Kandinsky and several of his friends to resign. It did appear, however, at the first show that Kandinsky and Franz Marc organized under the banner of the Blue Rider, in December 1911.

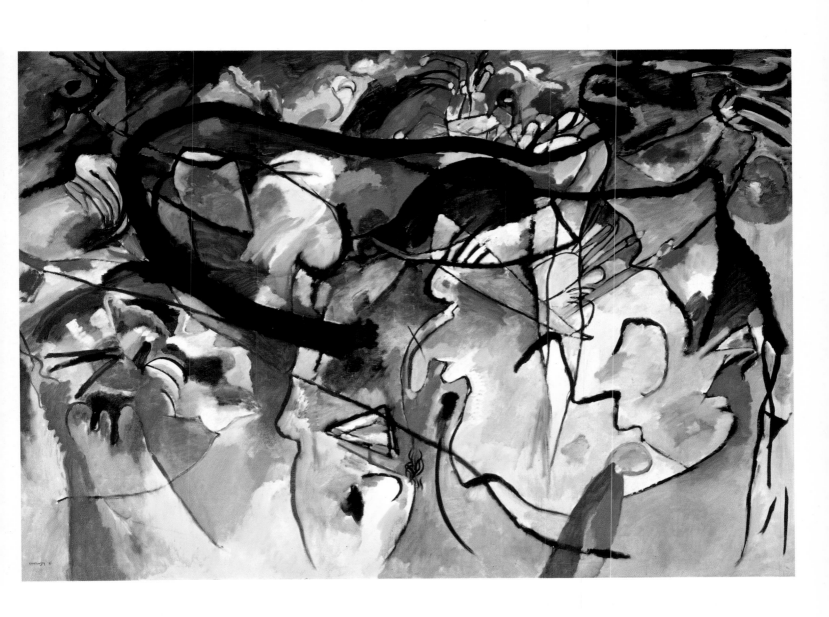

17. IMPROVISATION 26 (ROWING). 1912

Oil on canvas, 38⅜ × 42⅜" (97 × 107.5 cm)
Städtische Galerie im Lenbachhaus, Munich

The relatively explicit treatment of the earlier *Boat Trip* (plate 9), in which vessel, rowers, and pilot were schematically defined, is carried to a further degree of abstraction in *Improvisation 26 (Rowing)*. Such a development may partly be due to the designated category of the work, Improvisation, in which Kandinsky allowed himself greater freedom of execution than in either his works called Impressions or his Compositions. More significantly, however, the artist now approached a more pronounced degree of abstraction. His theoretical conclusions about a deepening language of form now found convincing expression in the works themselves.

Three pairs of nearly parallel black lines, suggesting oars, issue seemingly from nowhere, at the very center of the composition. Only closer scrutiny reveals the outlines of boatmen familiar from *Boat Trip*, which, as is so often the case in Kandinsky's oeuvre, are identifiable beyond doubt from related works on paper and, in this case, even a glass painting. Among many such works, an exquisite watercolor in Munich schematizes the black boat and oars, while red and yellow shapes no more than evoke the position of the oarsmen. In the present painting, the pilot, situated at the rear of a barely identifiable vessel, is reduced to a color blotch that nonetheless manages to convey the appropriate posture as foreshadowed in *Boat Trip*. Both he and a similarly represented mate are rendered in the colors assigned to them in the earlier work. But the former narrative has now given way to a disembodied intimation of the rowing gesture.

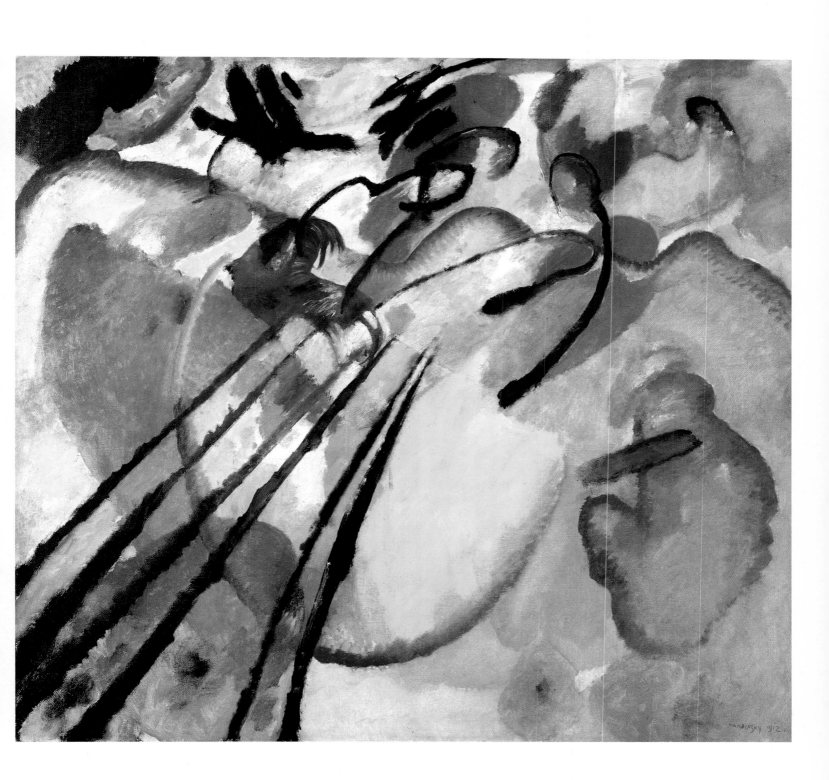

18. IMPROVISATION 27 (GARDEN OF LOVE II). 1912

Oil on canvas, 47⅜ × 55¼" (120 × 140 cm)
The Metropolitan Museum of Art, New York.
The Alfred Stieglitz Collection

The term Improvisation was used by Kandinsky to designate a group of paintings in which the observed data of the objective world are transcended, and at the same time deepened, through the free and autonomous use of the painter's language. In Kandinsky's words, the Improvisations are "largely expressions that have arisen suddenly and that are mainly subconscious processes of an inward character, i.e., impressions derived from 'inner nature.'" There are thirty-five numbered works so titled. All of them were completed between 1909 and 1914.

Two Improvisations have the same subtitle, *Garden of Love*. One of them was once in Russia; the other, at the Metropolitan Museum of Art, New York, may claim the distinction of being the first painting by Kandinsky to have been publicly presented in the United States. It came to the Armory Show, that pioneering exhibition of modern art in New York, in 1913, not long after its completion. Despite their having the same subtitle, the two works are quite differently conceived.

Improvisation 27, though relatively undefined in figurative terms, nevertheless presents us with rather overtly erotic elements. Embracing and reclining couples are rendered either in an emphatic color contrast (red and green, or even black and white), so as to stress the duality of the sexes; or, conversely, in an even tonality, perhaps to indicate the transcendence of that duality through the act of love. Freudian interpretations could, no doubt, be given for other, less explicit elements. But even without such an approach, the suggestively voluptuous shapes, the snakelike black strokes, and the interplay of earthen, sweetish pink and bluish hues are wholly capable of conjuring the sensuality suggested by the subtitle of this Improvisation.

82

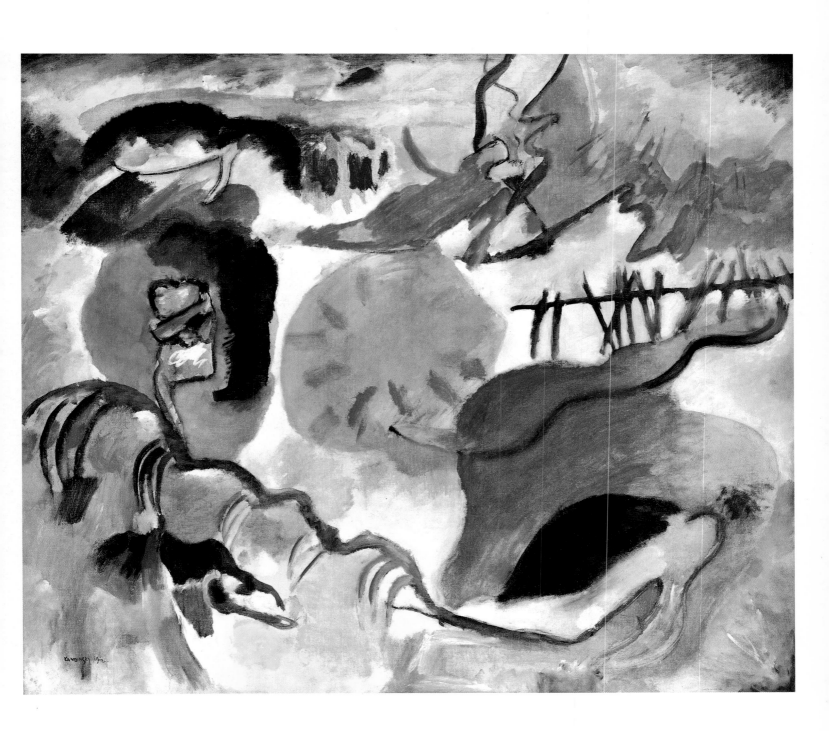

19. PAINTING WITH BLACK ARCH. 1912

Oil on canvas, 74⅜ × 78" (189 × 198 cm)
Musée National d'Art Moderne, Centre Georges Pompidou, Paris.
Gift of Nina Kandinsky

"Painting is a thunderous collision of different worlds which in mutual combat are destined to shape and name the new world." This sentence from Kandinsky's *Reminiscences* would appear to have a direct bearing on the work before us. Together with *Composition IV* and *Composition V* of 1911 (plates 15, 16), *Painting with Black Arch* ushers in what Will Grohmann called Kandinsky's "heroic" period—the years during which a number of large-scale paintings convey their content entirely through the power of abstracted form, now virtually unaided by decipherable references to objects. It is the phase that is most readily identified with Kandinsky's prime contribution, popularly perceived as his invention of abstract painting. Even if today that view seems oversimplified, it is arguable that in the years immediately preceding World War I, Kandinsky's theoretical advances were supported by the most telling masterpieces he ever produced.

In this monumental, nearly square canvas, three commanding, rocklike shapes, floating in space, appear to be on a collision course, suggesting some sort of cosmic calamity. Red and blue, often contrasted in Kandinsky's writings, heighten the dynamic tension of the principal shapes, which seem to be propelled with great force toward the center of the canvas. A second constellation of these shapes, held in more neutral hues, hovers above. The dominant color, at first concentrated in the clearly defined forms, is echoed in the painting's margins. The black, whiplike arch named in the artist's title provides, together with a related linear pattern, a rhythmic counterpoint to the areas defined by color. Space in this trans-human world is seen as a neutral field brought to life by subtle, almost hidden color accents. More than any preceding work, *Painting with Black Arch* evokes a cosmic vision that some critics trace to the artist's interest in theosophy.

Painting with Black Arch remained in the possession of Nina Kandinsky, who gave it to the Musée National d'Art Moderne. After her lifetime, a large number of works in various mediums were bequeathed to the Centre Georges Pompidou, thereby establishing that institution as one of only three with truly comprehensive holdings of Kandinsky's art.

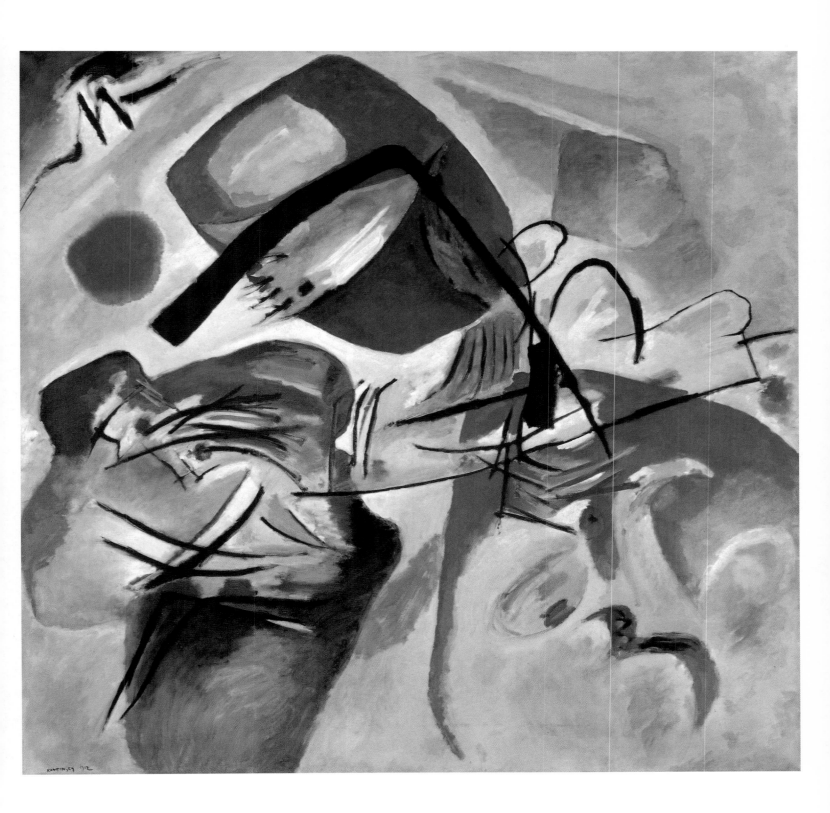

20. COMPOSITION VI. 1913

Oil on canvas, 76¾ × 118⅛" (195 × 300 cm)
The State Hermitage Museum, Saint Petersburg

In the two years, 1911–13, preceding the completion of *Composition VI*, Kandinsky concentrated on religious themes drawn from the Old and New Testaments. In addition to works dedicated to individual saints, there are versions of the Last Judgment, the Resurrection, All Saints, and the Horsemen of the Apocalypse, among other subjects. Many of these were painted on the reverse side of a pane of glass, a kind of painting designated by the German term *Hinterglasmalerei*. Among those that Kandinsky mentioned as sources for the present work was one glass painting, titled *Deluge*, whose present location is unknown.

In his *Reminiscences*, the artist spoke in detail about the genesis of *Composition VI*, from its playful beginnings to the final version, which in Kandinsky's mind no longer had any significant relationship to the original biblical theme. By then, its meaning derived from the broader ramifications of the word "Deluge," rather than from the re-creation of the specific Old Testament event, the artist explained.

In the same essay, Kandinsky took special pains to stress his concern with purely visual, spatial problems and with questions of perception. He referred, for example, to surface treatment, to rough and smooth passages, and to the effect of distance on the beholder. Further, he wrote about his deliberate muting of dramatic content in order to tame excessive responses to the work, thereby introducing a sense of calm into its generally turbulent mood. He touched on the subject of the location of the compositional center and admitted to its deliberate concealment. The artist's interest, at least with respect to the painting here discussed, was clearly formal rather than iconographic. It therefore would seem to contradict his purposes were one to insist too much on the presence of familiar ciphers, such as the evident memories of trees, mountains, sky, celestial bodies, birds, and boats, all of them largely overwhelmed by indeterminable black and red color areas, sawtoothed ovoids, and multicolored, soft-edged constellations.

Composition VI and the subsequent *Composition VII* (plate 23) are now in Russia, where the artist left them on deposit, together with other works, before his return to Germany in 1921.

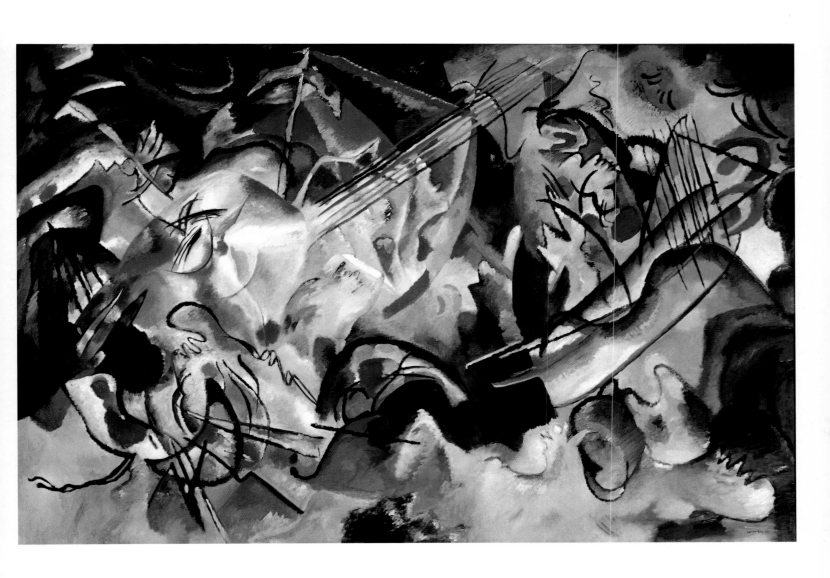

21. PAINTING WITH WHITE BORDER (MOSCOW). 1913

Oil on canvas, 55¼ × 78¾" (140.3 × 200 cm)
Solomon R. Guggenheim Museum, New York.
Gift of Solomon R. Guggenheim

As with *Composition VI* (plate 20), here too the artist provided his own analysis, emphasizing the graphic and coloristic features of the work rather than its figurative references. What interested Kandinsky were the carefully determined encounters between blue and red areas; the emergence of a center or of alternate centers; stark contrasts within tonalities; tensions between clear and smudged passages; and, lastly, the revelation of the border as the formal device that would give the composition its ultimate meaning.

The interior border is indeed a fundamental innovation, since its hard edge separates the inner action from the surrounding spaces. In none of Kandinsky's previous paintings had the territory of engagement been so distinctly set off from the other-worldly ambience that enfolds it. The new insight was not applied to his immediately following paintings, but it would have important implications for later stylistic developments.

Scholars, with good reason, have attached much importance to the conspicuous, gleaming lance-form, which, extending from the composition's center, aims at the fanglike shapes at the lower left. The white streak pointed at a grasping form recalls Saint George in the act of killing the serpent. This interpretation is supported by a series of preparatory drawings that leave little doubt as to the final version's thematic origin. Kandinsky did not deny this but at the time of his writing apparently did not consider the matter worth mentioning. Instead, he cited the inspirational experience of a recent visit to Moscow and added the name of his beloved city as a subtitle for the painting.

Completed in May 1913 between *Composition VI* (plate 20) and *Composition VII* (plate 23), *Painting with White Border* is one of the treasures of the Guggenheim Museum in New York. Baroness Hilla Rebay was the museum's founding director, when it was known as the Museum of Non-Objective Painting, and she was the official responsible for making it one of the three principal repositories of Kandinsky's artistic legacy. Rebay considered the work here discussed "non-objective" (a rather misleading translation of the German word *gegenstandslos,* meaning "without object" or "object-less") rather than merely "abstract." In her usage, the term "abstract" referred to a painting that resulted from a process of paring down, or abstracting from, natural forms, while a "non-objective" work, in her view, was one conceived without reference to natural forms from the outset.

Numerous works on paper completed in 1913 are designated as sketches or drafts. Executed with pencil or ink and watercolor, most of them are not visually relatable to the painting's final version.

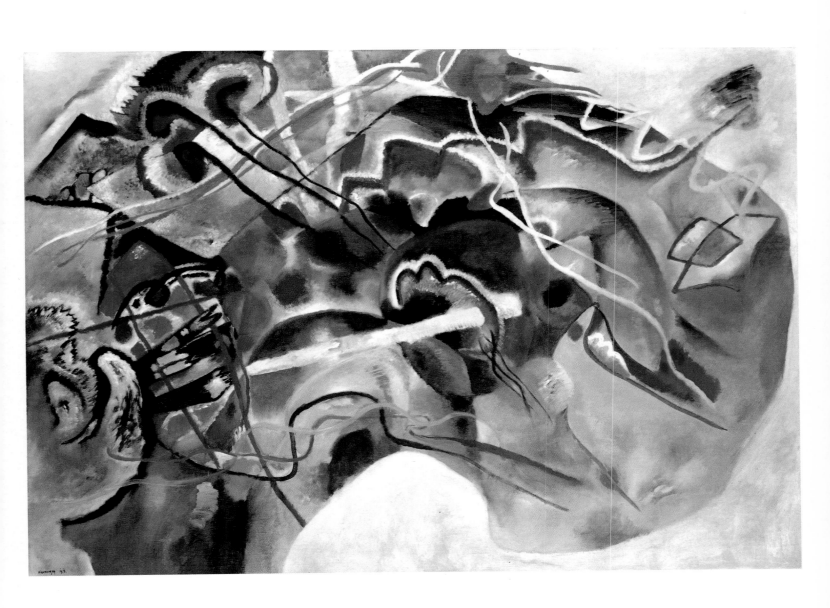

22. IMPROVISATION 34 (ORIENT II). 1913

Oil on canvas, 47¼ × 54¾" (120 × 139 cm)
The State Art Museum, Kazan

The location of *Improvisation 34 (Orient II)* was unknown until fairly recently. The work was one of many acquired for Soviet museums when Kandinsky was head of the Russian Purchasing Commission of the Museum Bureau. It resurfaced, together with others, in 1989, on the occasion of the first Kandinsky retrospective exhibition to originate in what was then the Soviet Union. The exhibition was also the first to include a significant sampling of Kandinsky's paintings and works on paper from Soviet provincial museums, such as the one in Kazan, which has *Improvisation 34* in its collection.

An oil painting titled *Improvisation 33 (Orient),* completed several months earlier, as well as five watercolors, and preparatory drawings shed light on this work, since all of them maintain common features in various degrees of explicitness. *Improvisation 34* appears wholly "non-objective" at first glance, exceeding the degree of abstraction generally seen earlier. The related works, however, all include the motif of a reclining figure, positioned parallel to the picture's lower edge. Disembodied though hardly de-eroticized, that motif becomes recognizable in the final version as well.

Kandinsky characteristically "sets the stage" by introducing emphatic diagonal accents in the upper left corner of the canvas. Oval shapes as well as sweetly colored dabs alternate with calligraphic superimpositions to intimate an "Oriental" flavor. Paint is applied loosely, and the deep colors are so balanced as to prevent the domination of any one hue. The tonal disposition corresponds to the painting's structure, receding from the fullness of the upper left to the virtual vacuum of the lower right. In parallel fashion, exuberant color gradually gives way to lighter, more neutral values. The lightness of touch, the joyousness of color, and the sureness of Kandinsky's shaping intuition all relate this newly revealed painting to such major works as *Black Lines I* (plate 24).

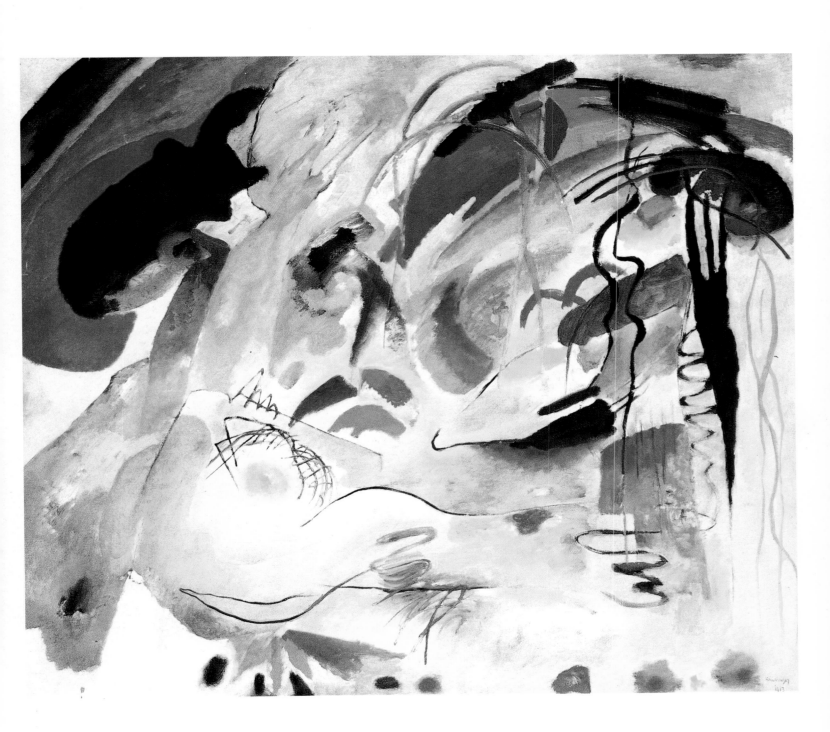

23. COMPOSITION VII. 1913

Oil on canvas, 78¾ × 118⅛" (200 × 300 cm)
The State Tretiakov Gallery, Moscow

Even within the category of paintings that Kandinsky himself designated as his most ambitious and comprehensive, *Composition VII* stands out as a work of extraordinary intensity and power, and it is generally accepted as the artist's *magnum opus*. Yet this is one of the most difficult, not to say impenetrable, creations in all of Kandinsky's work, a painting whose imagery leaves us little by way of even vestigial subject matter, while overpowering the viewer with the sheer force of its energetic shapes and radiant colors.

Dominating the work, and imposing itself on the viewer, is the Composition's central "eye"-shape. It functions as an ordering element, an emblem of human intelligence, piercing the surrounding chaos to establish contact with the viewer. Although the painting is seemingly unstructured, a sense of direction nevertheless emerges through force lines moving, in a dynamic crescendo, from the upper left toward the center. In the process, echoes are evoked along the right margin and eventually exhausted at the lower left, where dominant primaries and superimposed linear accents yield to an amorphous, monochromatic area. We witness thereby a containment of "all-over" painting comparable to what was encountered in *Composition V* (plate 16) and *Painting with Black Arch* (plate 19). At the same time, the contrapuntal relationship between color areas and linear patterns prefigures the compositional solution of *Black Lines I* (plate 24).

The creation of *Composition VII* involved more sketches, studies, and related works in various mediums than any comparable painting by Kandinsky. Of these, some are only remotely connected to the final work, while others elaborate on features that are conspicuously evident in it. They include definable, though largely non-referential, shapes that interlock at levels of shallow depth; and sharp, often crosshatched black lines, which alternate with color areas whose jagged horizontals and faceted curved shapes avoid angles.

This large, imposing canvas was among the paintings that remained in Russia at the time of Kandinsky's departure in 1921. Doomed for many years to remain unseen during the era of Stalinist rule, when abstract works were removed from public view, it now ranks among the proudest possessions of the State Tretiakov Gallery, Moscow.

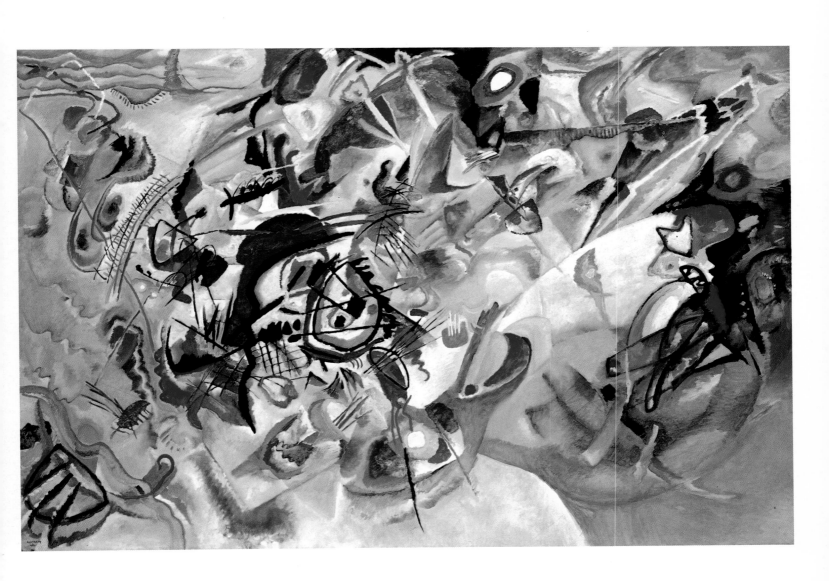

24. BLACK LINES I. 1913

Oil on canvas, 51 × 51⅜" (129.4 × 131.1 cm)
Solomon R. Guggenheim Museum, New York.
Gift of Solomon R. Guggenheim

Toward the end of 1913—a year filled with exhibitions, publications, and travel—Kandinsky completed *Black Lines I*. Shapes in complementary colors, with the primaries plus green dominant, float weightlessly in a palpitating gray-yellow space, adjoining and overlapping over a flat surface. A spidery linear web follows its own rhythms while lending structure to the composition as a whole. The painted black lines are energy carriers and directional signs, and at times they are the agents of an explosive action that contrasts with the slow pulsation of the colored shapes. A stage for these complex dynamics is provided by the recurring device of heavy, parallel diagonals in the upper left corner—in this instance, a green triangle supported by an attenuated orange arch—and further provided by a deep red curtain-form that acts as a stabilizing border running the full length of the painting's right edge. Peg Weiss ascribed the artistic success of *Black Lines I* to Kandinsky's ability to deploy what is essentially a graphic style of line in painting, and she saw his free scattering of graphic hieroglyphs as prophetic of later twentieth-century art, presumably meaning Abstract Expressionism. In this context, one may recall that it was in reference to Kandinsky's work that the term "abstract expressionism" had been coined in the first place.

Scholars continue to debate the degree of abstractness in this and other canvases of the same period. But Kandinsky himself counted *Black Lines I* among those works devoid of any other than purely formal content.

Black Lines I constitutes one of the artist's most successful efforts to emulate the attributes of musical compositions. The belief that the development of painting had arrived (or at least aspired to arrive) at the condition of music was, with Kandinsky, an article of faith. It presupposed a capacity to structure plastic thought in wholly abstract terms analogous to the elements of music—melody, harmony, and rhythm—and to articulate its meanings accordingly.

There are several related works on paper, including drawings, watercolors, and gouaches. Some of them are closer than others to the final oil painting, and some have a bearing as well on themes from *Composition VII* (plate 23).

In 1937, Solomon R. Guggenheim gave this painting, together with many other works by Kandinsky, to the foundation named for him.

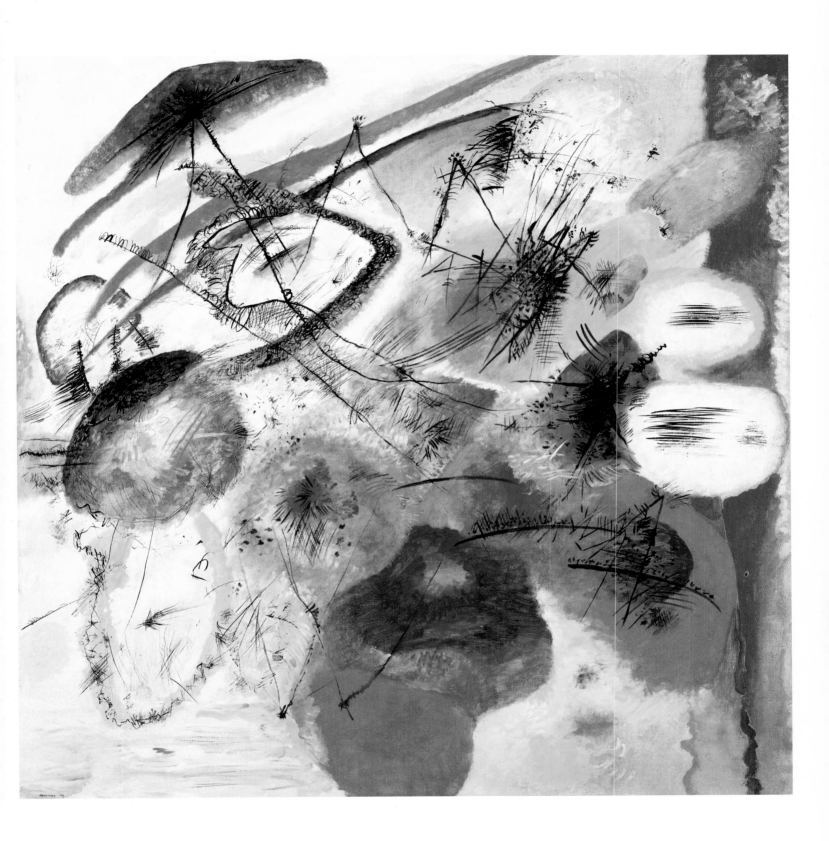

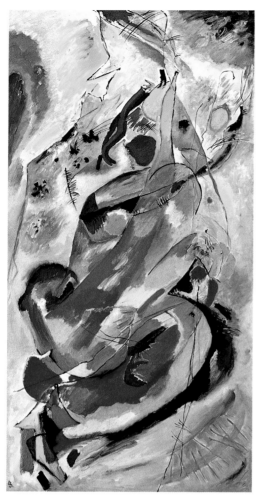

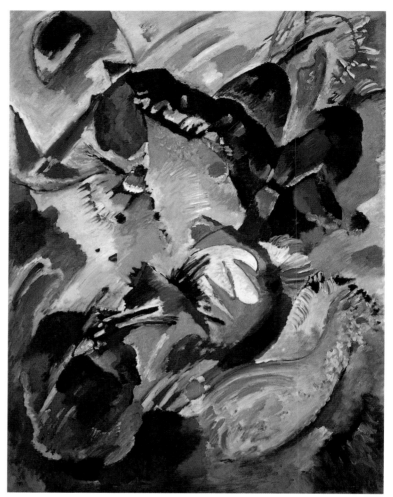

25A

25B

25. FOUR PANELS FOR EDWIN R. CAMPBELL

The four untitled panels commissioned by Edwin R. Campbell, an American collector who resided in Manhattan before and during World War I, may be discussed here together, since they were so conceived by both the patron and the artist. The panels were painted in May–June 1914, which is to say shortly before the outbreak of World War I. They must therefore be considered among the last works that Kandinsky completed in Munich. On the basis of numbered photographs once in Gabriele Münter's possession, a sequence from 1 to 4 has been established for the panels, at least tentatively. The many associated works in various mediums were correlated with the panels through the efforts of Angelica Rudenstine, while cataloguing the painting collection of the Guggenheim Museum.

The four works are practically of equal height but of unequal width, since their proportions were determined by architectural exigencies. From relevant correspondence it is known that the panels were intended as decorations for a rounded entrance hall in Campbell's Park Avenue apartment, where they were installed on their arrival from Europe during the war.

The Kandinsky scholar Kenneth Lindsay has proposed a reading of the panels in terms of the four seasons, which, in view of the decorative character of the works, is a tempting interpretation. The mood, and what might be felt to be the respective

25A. PANEL FOR EDWIN
R. CAMPBELL NO. 1 1914

Oil on canvas, 64 × 31½"
(162.5 × 80 cm)
The Museum of Modern Art, New York.
Mrs. Simon Guggenheim Fund

25B. PANEL FOR EDWIN
R. CAMPBELL NO. 2. 1914

Oil on canvas, 64⅛ × 48⅜"
(162.6 × 122.8 cm).
The Museum of Modern Art, New York.
Nelson A. Rockefeller Fund (by exchange)

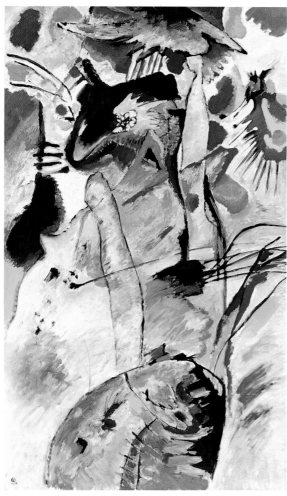

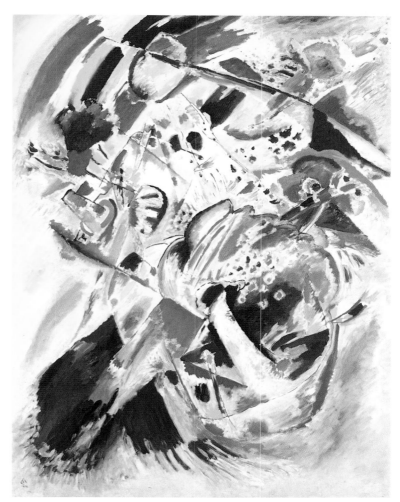

25C 25D

"temperature," of each of the panels adds plausibility to the argument. However, the seasonal attributes that suggest themselves to a viewer are in conflict with the sequence as surmised from Kandinsky's records. Current scholarship, in any case, tends to reject the proposed reading, but *The Four Seasons* has, nevertheless, become a familiar designation of the Campbell panels.

Separated on leaving the Campbell residence, the four works subsequently entered the collections of the Guggenheim Museum and of the Museum of Modern Art. The two wider panels, sometimes known as *Winter* and *Fall*, came to the Guggenheim, and *Spring* and *Summer* to the Modern. In an exchange of paintings between the two institutions, arrived at in 1982 and motivated at least in part by the wish of all concerned to see the panels reunited, the two Guggenheim panels entered the collection of the Museum of Modern Art, where, at long last, the entire sequence may now be seen under one roof.

Watercolors and india ink drawings are not always relatable in detail to the four panels, since they may suggest other oil paintings as well, such as *Painting with White Border* (plate 21). The watercolor *Study for a Panel for Edwin R. Campbell* in the Städtische Galerie im Lenbachhaus, Munich, is among the most expressive of such works.

25C. PANEL FOR EDWIN
R. CAMPBELL NO. 3. 1914

Oil on canvas, 64 × 36¼"
(162.5 × 92.1 cm)
The Museum of Modern Art, New York.
Mrs. Simon Guggenheim Fund

25D. PANEL FOR EDWIN
R. CAMPBELL NO. 4. 1914

Oil on canvas, 64¼ × 48¼"
(163 × 123.6 cm)
The Museum of Modern Art, New York.
Nelson A. Rockefeller Fund (by exchange)

26. PAINTING ON LIGHT GROUND. 1916

Oil on canvas, 39⅜ × 30⅝" (100 × 78 cm)
Musée National d'Art Moderne, Centre Georges Pompidou, Paris.
Gift of Nina Kandinsky

The outbreak of the war forced Kandinsky's immediate departure from Munich, where, as a Russian citizen, he would have been considered an enemy alien. During the period of extensive travel that followed, he limited himself for some time to works on paper, producing not a single oil painting in 1915. In 1916, he created three canvases, of which only *Painting on Light Ground* survives.

This is among the first of Kandinsky's works to begin making the transition from his Expressionist style of the prewar period to what will eventually become his geometric constructions years later at the Bauhaus. *Painting on Light Ground* was completed early in 1916, while Kandinsky was preparing for a show in Stockholm. According to Vivian Endicott Barnett—who continues the monumental task of cataloguing Kandinsky's oeuvre, following the death of Hans Konrad Roethel—it is the only surviving painting from Kandinsky's visit to Sweden, which also marked the artist's final separation from Gabriele Münter.

Painting on Light Ground thus is transitional in several senses, geographical and biographical as well as stylistic. The prophecy of *Painting with White Border* (plate 21) is now fulfilled: there is a break with the "all-over," dispersed kind of composition in favor of a composition that is clearly delineated against a light background. The heavy black outline of the central image strongly contrasts with the pink and bluish pastels of the margins. The work as a whole is structured in three tiers—background, "stage," and action—although the last two remain ambiguously interwoven. A dynamic sense of depth, almost of a vortex, is created as the eye is drawn inward from the painting's margins to its center. Concentric circles, spheres, and tooth-edged ovoids, boat- and moon-shapes, plantlike growths, and agitated flames all gravitate toward something like an enchanted lake. The explicitness of treatment in the existing related drawings reveals the painting's suppressed figurative content.

As a signature, the artist used the capital letter K, framed in a V-shape that is closed off with a line to make a triangle. It is a monogram device that occurs in certain paintings as early as 1911 but is used consistently on canvas only from 1914, as for example in the Campbell panels (plates 25A to 25D).

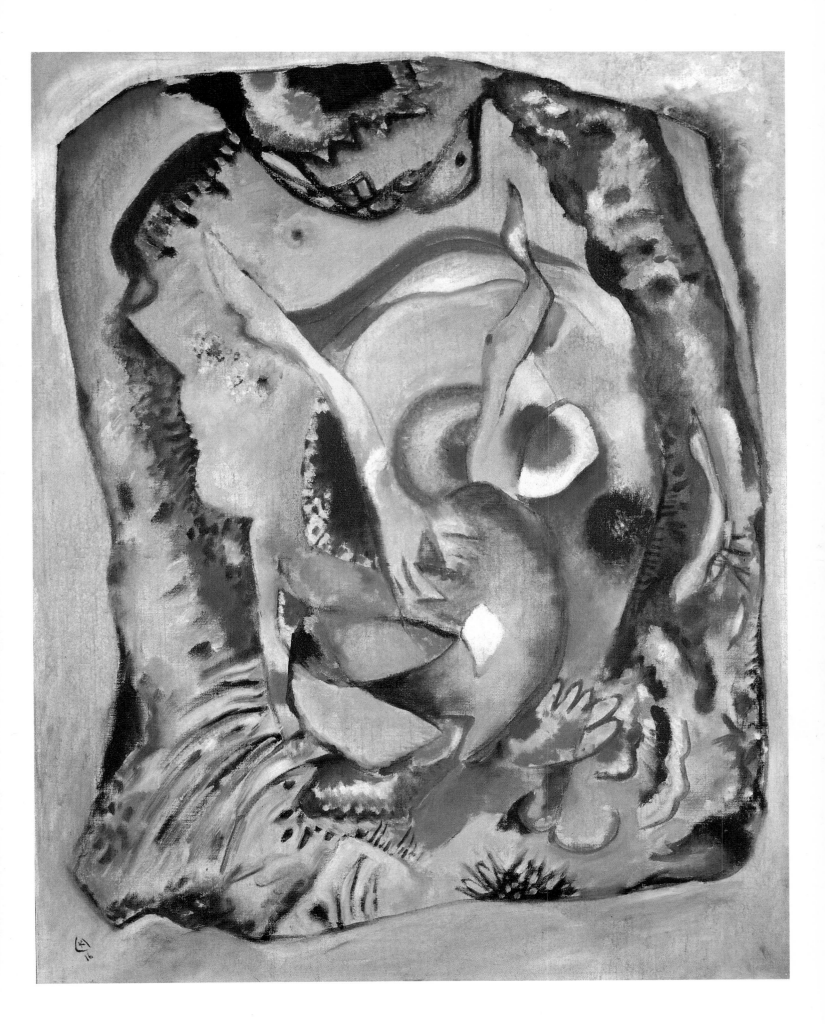

27. TWILIGHT. 1917

Oil on canvas, 41⅜ × 52¾" (105 × 134 cm)
The State Russian Museum, Saint Petersburg

Paintings on canvas remained quite infrequent throughout the Revolutionary period, which Kandinsky, now over fifty years old, spent in Moscow, having just married Nina Andreevskaia, the young daughter of a Czarist colonel. Some exceptions apart, paintings as well as works in other mediums seem to stray from his central creative pursuits. A group of representational works recording life in the country and at the Achtyrka dacha, canvases that are at times almost indistinguishable from his earliest efforts at the beginning of the century, alternate with modish Biedermeier bagatelles, some recalling the early versions of *Crinolines* (see plate 6). Whatever the reasons for such digressions, canvases of central importance executed in Russia prior to 1920 are few. Those that exist, such as *In Gray,* now in the Centre Georges Pompidou, Paris, are transitional in character.

By comparison with *Painting on Light Ground* (plate 26), *Twilight* is somber in color and mood. As with the earlier painting, here the conception moves toward Kandinsky's Constructivist-related phase, which would develop later on. But the multiple, intensely colored shapes floating in space are less clearly delineated and separated from their background than is the aggregate mass of the earlier work. *Twilight* appears to be painted from the top down, with two distinct constellations tenuously linked to each other. The background suggests a turbulent sky with a mighty rainbow spanning mountaintops. Again, as in *Painting on Light Ground*, overlapping forms—partly sustained by a newly developing abstract vocabulary, but also by imagery reminiscent of the Munich years—here mix freely. They act within a context equidistant from the work the artist left behind and that which awaited realization after the Russian transition.

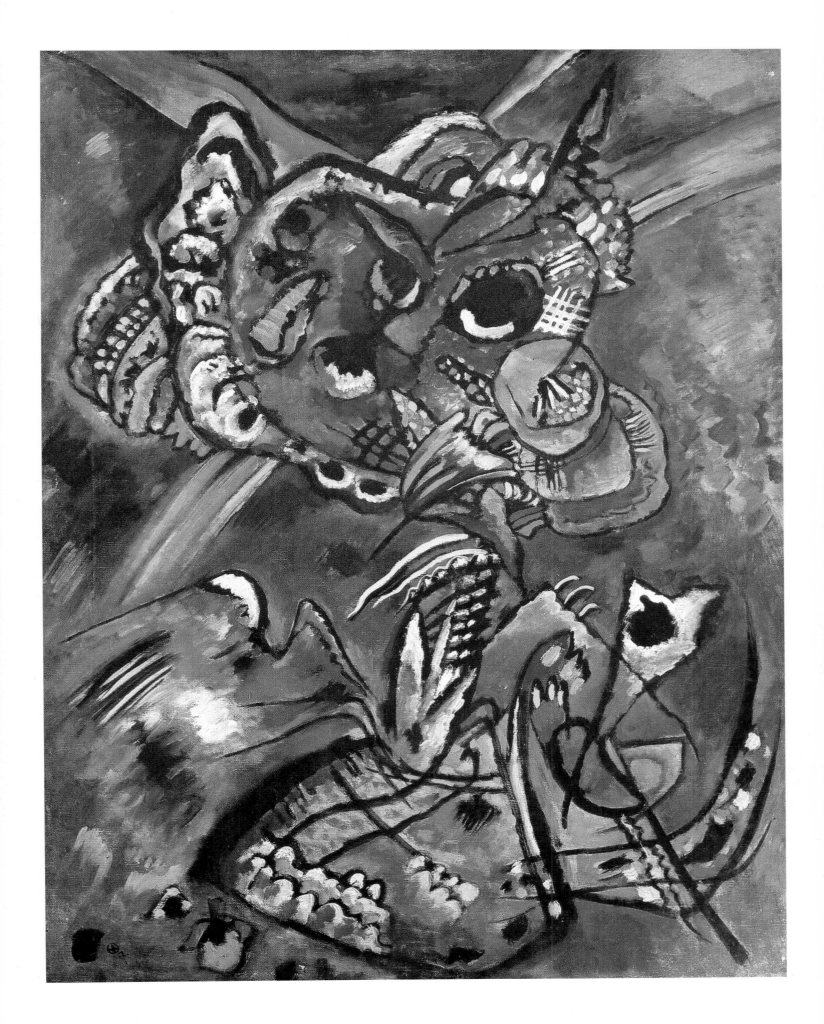

28. RED OVAL. 1920

Oil on canvas, 28¼ × 28⅛" (71.5 × 71.2 cm)
Solomon R. Guggenheim Museum, New York

The immediate post-Revolutionary period, from late 1917 to the middle of 1919, drew on Kandinsky's leadership and organizational talents at the expense of his artistic productivity. His ability to organize artists' groups, already demonstrated in the Munich period, reasserted itself during the short "honeymoon" between the Bolshevik regime and the more rigid art establishment that marked the early years of the Soviet Union. Only toward the end of the Russian interlude, by 1920, did his output of important oil paintings, such as *Red Oval,* increase again.

This small, square canvas presents a tripartite division between, first of all, the many shapes and colors lying on the surface; then, the intermediate, bright yellow rectangular plane against which this imagery is projected; and finally, a stained, green square that functions as background. But as if to stress the ultimate unity of these three levels, the fore- and middle ground spill into the background, thereby softening somewhat an otherwise distinct separation. A deep red oval sun, off the canvas's center, preempts the viewer's attention, and only gradually are other elements admitted—pale moons, reminiscences of boats, oars, and rowers, as well as color intimations of green growth and blue mountain ranges. The extension of such images from the surface plane to an undefined "beyond" suggests a dialogue between here and there—between measurable spaces and a surrounding infinity—a dynamic that becomes the implicit theme of this prescient work.

All visual evidence in *Red Oval* points to Kandinsky's awareness of Kazimir Malevich and of Suprematism, as Vivian Endicott Barnett rightly points out in her catalogue of Kandinsky's works at the Guggenheim Museum. Yet other scholars remain cautious about this subject, which invites further research.

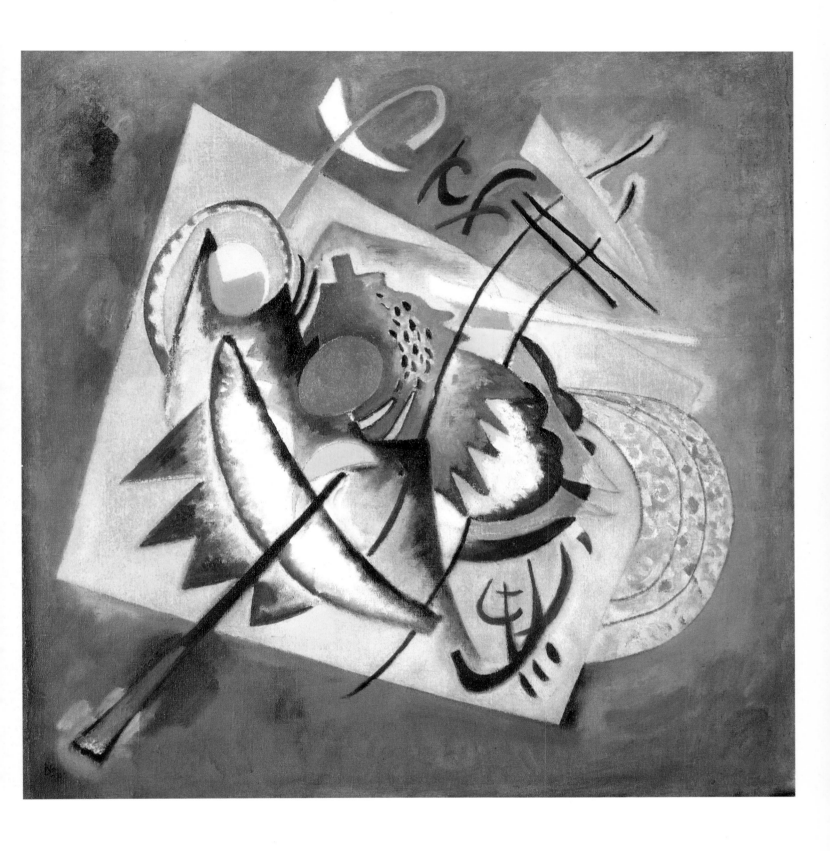

29. RED SPOT II. 1921

Oil on canvas, 53⅞ × 71¼" (137 × 181 cm)
Städtische Galerie im Lenbachhaus, Munich.
Permanent loan from the Bayrische Hypotheken- und Wechselbank

The Städtische Galerie im Lenbachhaus, Munich, was given the sizable and important
collection of works that remained with Gabriele Münter after her separation from
Kandinsky. Among the museum's few subsequent acquisitions, intended to link those
Munich-period works to later phases of Kandinsky's development, is *Red Spot II*,
painted early in 1921, the year of the artist's departure from Moscow.

This canvas shows only superficial similarities to the work with the same title that
is designated as number I. *Red Spot II* markedly advanced Kandinsky's progress toward
a new idiom. Among its attributes are a firmer structure, a livelier sense of implied
movement, and a greater compositional clarity, as well as an increased schematization
of abstract images and reminiscences. Furthermore, the interaction between planes
is rendered more readable, as the images surrounding the "red spot" of the title have
gained in size and clarity. The white intermediary platform now remains separate
from the dark background areas, contrasting sharply with them through hard edges
whose corners have been blunted. The colorless background itself is suggestive of
infinite spaces surrounding a finite world. In juxtaposing colored planes with mono-
chromatic areas, Kandinsky implied the simultaneous validity of distinct levels of
reality. *Red Spot II* is not yet heavily dependent on geometry as the carrier of precise
meanings, but it is a key work pointing in that direction.

As in *Red Oval* (plate 28), elements of a Constructivist repertoire are clearly iden-
tifiable, increasing the likelihood of a relationship between Kandinsky and some of
his Russian fellow artists during the post-Revolutionary period.

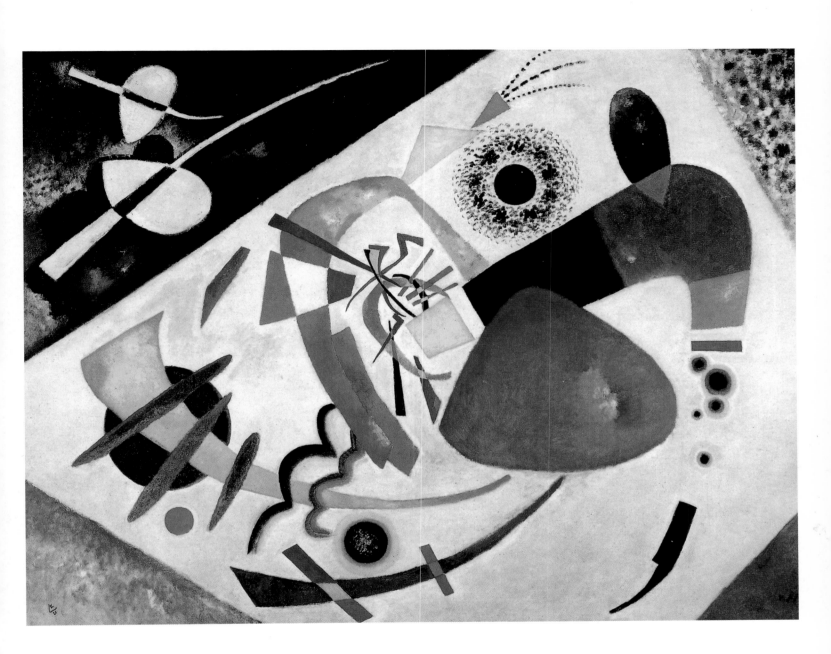

30. COMPOSITION VIII. 1923

Oil on canvas, 55⅛ × 79⅛" (127 × 200 cm)
Solomon R. Guggenheim Museum, New York.
Gift of Solomon R. Guggenheim

Early in 1922, at the invitation of the directing architect, Walter Gropius, and some friends from prewar days, Kandinsky accepted a teaching position at the Bauhaus school in Weimar, Germany. This was the institution which from 1919 to 1933 attempted to bridge the unproductive separation between artists and architects on the one hand and craftsmen and artisans on the other, hoping to promote instead a fruitful collaboration between them. For Kandinsky, the Bauhaus provided a congenial milieu in which to consolidate the creative experiments of the preceding several years and embark on his second major stylistic development, that of geometric construction.

Composition VIII, because of its size and commanding presence, but even more because of its serene formal disposition, may be considered the masterpiece of the Bauhaus years. The lingering painterly forms and textural effects of the transition period are gone. Instead, geometric elements—triangles, circles, and semicircles, regular and irregular squares, half-crescents, and single, parallel, and crossing lines and bars—float in free but measured interplay, in and on an animated space. What in some earlier Compositions appeared as multilevel interaction has now given way to an aesthetic of well-tempered placement, as elements are situated in a light-filled space of subtly modulated colors.

If the theoretical foundation of Kandinsky's Expressionist paintings was his treatise *On the Spiritual in Art,* the case for the geometric, Bauhaus period was made in a volume titled *Point and Line to Plane (Punkt und Linie zu Fläche),* which the artist had begun to draft as early as 1914. The volume appeared within a series of Bauhaus publications in 1926. Reflecting Kandinsky's dual orientation, as both a painter and a teacher, *Point and Line to Plane* substituted a new classicism and a collective objectivity for the essentially Romantic and individualistic concerns of pre-Revolutionary times. Perhaps more compellingly than any other Bauhaus painting, *Composition VIII,* with its airy plots and subplots, testifies to Kandinsky's newfound direction.

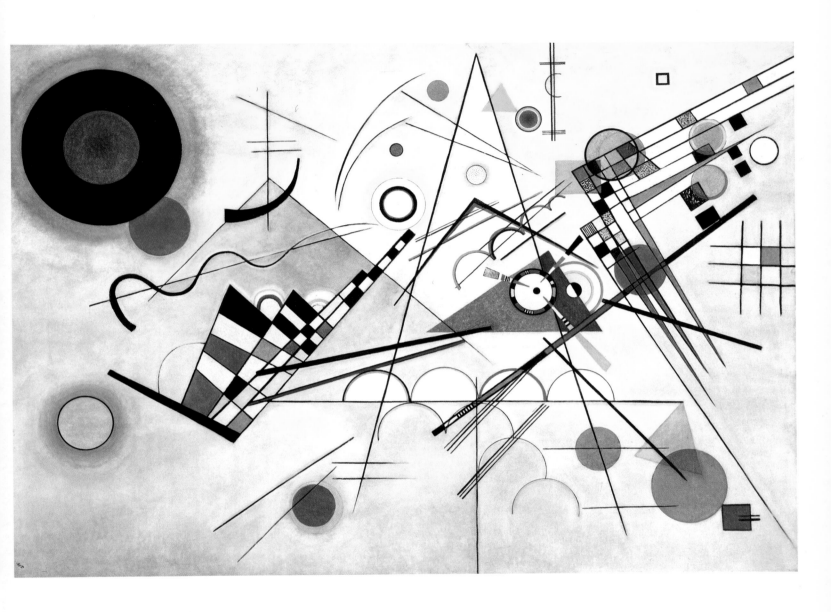

31. YELLOW-RED-BLUE. 1925

Oil on canvas, 50⅜ × 79⅜" (128 × 201.5 cm)
Musée National d'Art Moderne, Centre Georges Pompidou, Paris.
Gift of Nina Kandinsky

The Bauhaus, which had opened in Goethe's town of Weimar in 1919, increasingly came under attack for its avant-garde policies and production. By 1925, the combination of a philistine populace and the political agitation of a proto-Nazi party was exerting more pressure on Walter Gropius and his colleagues than they could withstand. In June of that year, the Bauhaus removed itself to the more hospitable city of Dessau, where it would flourish, in specially constructed quarters, until the fall of 1932 (at which time its activities there too were terminated). *Yellow-Red-Blue,* completed in the spring of 1925, is one of Kandinsky's last achievements of the Weimar period.

This sizable, emphatically horizontal canvas invites a reading from left to right, following the sequence of its title. It is constructed around two compositional centers, and within that framework it deals explicitly with the sequence of the three primary colors. Combining two contrasting shapes with three different hues, it generates an intriguing two-versus-three complexity well known to musicians. The aggressively yellow area on the left, constrained by an open-ended rectangle, opposes the large blue circle on the right. Between these two poles lie churning reds in geometric and biomorphic shapes.

There is nothing schematic about this catalogue of primaries or about its juxtapositions of shapes, for each element is muted almost as fast as it makes its discrete appearance. Thus, the active yellow plane is surrounded by a calming light-brown aura; the central reds are dampened by darker tones, ending in black; and the blue circle is partly covered, and decidedly reduced in its radiating potential, by multicolored forms.

As already observed in *Composition VIII* (plate 30), shapes float in space without the unifying intermediary plane that had often accompanied the previous, transitional stage. Somewhat in the manner of certain Munich abstractions, such as *Composition V* (plate 16), a polyphony of black lines and planes completes this rich farewell to Weimar.

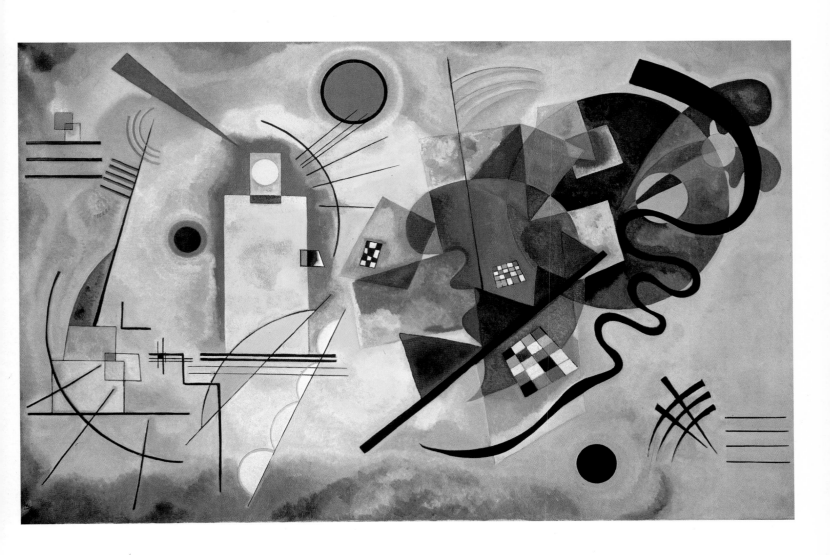

32. SEVERAL CIRCLES. 1926

Oil on canvas, 55¼ × 55⅜" (140.3 × 140.7 cm)
Solomon R. Guggenheim Museum, New York.
Gift of Solomon R. Guggenheim

Several Circles, surely among the most perfect of Kandinsky's creations, was completed early in 1926, not long after the Bauhaus moved from Weimar to Dessau. During the Bauhaus period, circles had assumed a place of importance which Kandinsky himself compared to that held by the horse-motif in an earlier phase. While, as Will Grohmann pointed out, the circle had become the sole motif in several works between 1923 and 1929, *Several Circles,* together with a painted preparatory sketch one half its size, is the first oil painting exclusively devoted to that theme. It would remain so except for two subsequent, distinctly lesser works. In *Point and Line to Plane,* published in the year that *Several Circles* was completed, the artist had inspiring things to say about the circle. The circular form in itself was not the object of his fascination, however, but rather its evocative powers, through which hidden meanings were revealed.

Scores of small, round shapes, some contained within others, some overlapping, orbit about, or sometimes within, a dominant blue circle surrounded by a shining aura. These multicolored constellations float on a modulated black surface, which, through the nuances of its texture, suggests greater or lesser depth, as in water seen from a height. *Several Circles* is, in part, pure geometry and as such engages our rational faculties. But the painting is also pure magic, possessed of mysterious, revelatory powers. For circles, and by extension celestial bodies, orbiting through the universe, speak to our emotions, reminding us that insignificant humanity participates in a cosmic order.

The art historians Sixten Ringbom and Rose-Carol Washton Long have written extensively about Kandinsky's contacts with theosophy and anthroposophy, and Jelena Hahl-Koch has recently documented the artist's lively interest in astrology as well. *Several Circles,* while not limited to such interpretations, certainly touches a chord of the sounding cosmos.

This Guggenheim painting, like some others, was bought at auction following the Nazis' infamous removal of so-called "degenerate art" from German museums in 1937. Through its attributes of perfection and mystery, it exerts an appeal that is simultaneously mental and spiritual. The painting assumed a place of particular distinction within the oeuvre of the now sixty-year-old artist.

33. ON POINTS. 1928

Oil on canvas, 55⅛ × 55⅛" (140 × 140 cm)
Musée National d'Art Moderne, Centre Georges Pompidou, Paris.
Gift of Nina Kandinsky

The Dessau period was a prolific one for Kandinsky. The urge to realize a number of accumulated pictorial ideas led him in quick succession from work to work—at times, to be sure, with lesser qualitative results. Masterpieces, such as *On Points,* therefore stand out more conspicuously than in periods of more measured production.

With dimensions almost identical to those of *Several Circles* (plate 32), executed two years before, the painting stands in some respects as a contrasting elaboration of the earlier work. The unified subject matter of the former here gives way to a complex dialogue between circles and triangles, two of the basic elements considered in *Point and Line to Plane,* the Bauhaus publication that in the year of this painting went into its second edition.

Five large triangular structures rest their acute angles on the top bar of a three-tiered base. Their upper components are reinforced by smaller triangles, some inverted, others functioning as arrows. The objects of their aggression are several circles, seven to be exact, with one dominating at the upper left. A solitary pinkish-red square resting on the base completes the catalogue of primary shapes. In contrast to the majestic calm of *Several Circles,* the present work is agitated, as its main forms perch precariously and in defiance of the laws of gravity on an unsupported, floating base. In keeping with such emphatic lability, the lively brushstrokes avoid the evenness seen in *Several Circles.* The color triad harks back to *Yellow-Red-Blue* (plate 31) but is here deployed to even more ambiguous effect.

The tension and unrest of *On Points* are not without parallels in Kandinsky's life at this time. The decision to acquire German citizenship was certainly not arrived at without inner conflict, since under the existing political circumstances it sealed the artist's final withdrawal from his native land and, incidentally, surrendered any possible claim to the works left there. In view of the fateful developments that were then visibly accelerating in his newly adopted country, the decision turned out to be even more problematic than it seemed.

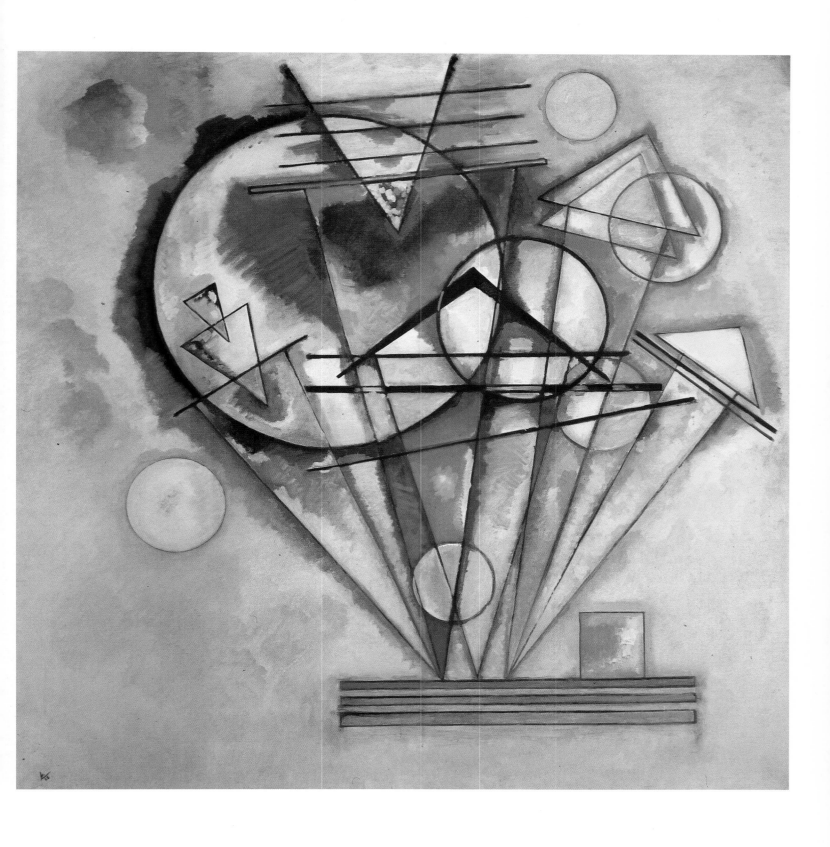

34. THIRTEEN RECTANGLES. 1930

Oil on cardboard, 27⅜ × 23⅜" (69.5 × 59.5 cm)
Musée National d'Art Moderne, Centre Georges Pompidou, Paris.
Bequest of Nina Kandinsky

The circle, the triangle, and the rectangle are the main vehicles of Kandinsky's geometric theories. They appear conspicuously in the artist's Bauhaus production and embody the pictorial grammar that he was striving for. But only in exceptional cases are these three component parts of the geometric edifice found in total isolation from one another. *Thirteen Rectangles,* an oil on cardboard completed in June 1930, constitutes such an exception, together with *Two Squares* of the same period and a watercolor titled *Lyrical Rectangle,* which was added a year later. In this sense, *Thirteen Rectangles* is to the quadrangular mode what *Several Circles* (plate 32) is to the circular.

Largely interlocking, at times marginally overlapping, and in a few instances unattached, the rectangles and squares are cast in primary colors and float with restrained elegance on a neutral light-green background. The severity of the composition and the considered placement of geometric shapes make this work the artist's closest approach to the principles of Dutch Neoplasticism, as practiced by Piet Mondrian.

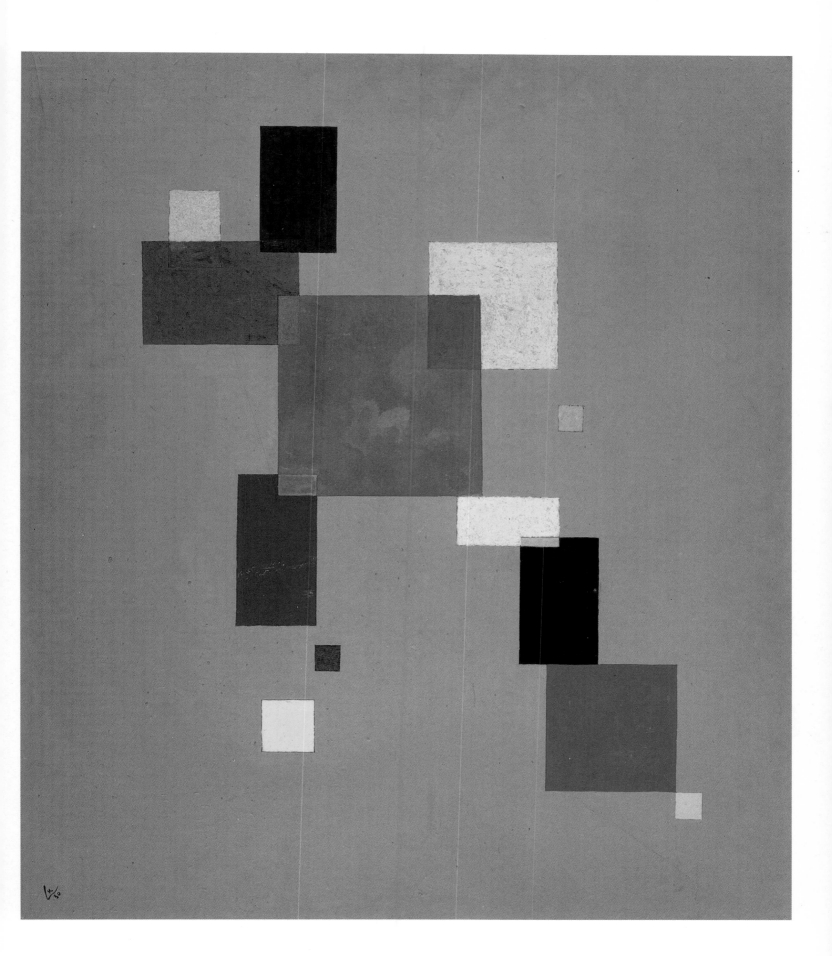

35. DEVELOPMENT IN BROWN. 1933

Oil on canvas, 41⅜ × 47¼" (101 × 120.5 cm)
Musée National d'Art Moderne, Centre Georges Pompidou, Paris

The year 1933 was a fateful one for Germany and for the world. After years of prov-ocations and subversions, the Weimar Republic was effectively overturned and the National Socialists assumed full power. The Bauhaus, which a year earlier had moved from Dessau to Berlin, was closed, and the remnants of its once formidable faculty, charged with cultural Bolshevism, were dispersed. Kandinsky, reluctant to believe the worst, was among the last to leave as the Nazi flood closed in. From Berlin, he made an exploratory trip to Paris, then took up residence in the quiet suburb of Neuilly-sur-Seine, where, with his wife Nina, he was to remain for the last eleven years of his life.

Development in Brown, executed in August 1933, thus became his last work to be completed in Germany. As before, Kandinsky's moving to a different country was to coincide with a stylistic reorientation, subtle at first but finally quite significant. It is only barely foreshadowed here, for the present work still bears the marks of the geo-metric Bauhaus idiom.

Overlapping hard-edged planes, orthogonal or circular, close in from both sides on fragile crescents and triangles, which maintain themselves against the deep-brown tonality in a light central area from which all escape routes are barred. The somber mood of the work is hard to dissociate from the ominous world events of the time or from the artist's own darkening outlook, but it would nonetheless be misleading to suggest a direct relationship between them.

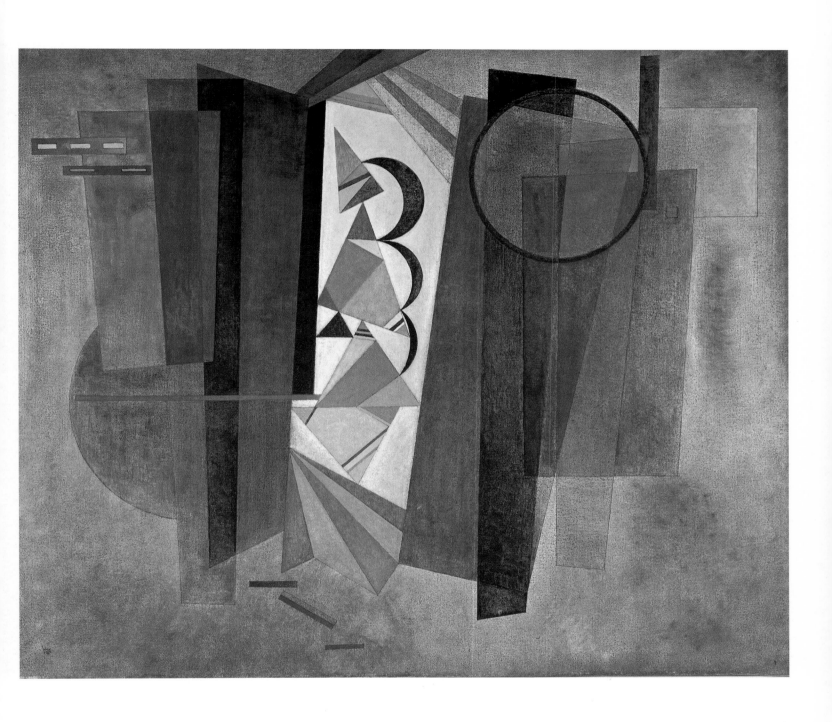

36. COMPOSITION IX. 1936

Oil on canvas, 44⅝ × 76¾" (113.5 × 195 cm)
Musée National d'Art Moderne, Centre Georges Pompidou, Paris

Early in 1936, as Kandinsky approached the third year of his Parisian exile, he apparently felt the need to summarize newly gained insights in one of those rare works that he designated as Compositions. This was the first work so specified since 1923, when, in creating *Composition VIII* (plate 30), he had been similarly motivated after accommodating to his new life at the Bauhaus in Weimar. The present work is notable for its large size and formal perfection. *Composition IX* also enjoys the distinction of being the first painting by Kandinsky purchased by the French state.

A firm architecture underlies the playful surface treatment of this work, thus perpetuating a kind of contrast or tension that the artist had deployed in earlier stages of his development. Kandinsky's alternate title for this canvas, *The One and the Other*, acknowledges his interest in the linking of such polarities. In structuring the work, the artist modified his earlier experiments with superimposed planes, but without compromising a sense of overall flatness. Two corner areas, the yellow upper left and the greenish lower right, may be read as background against which four hard-edged, diagonal stripes are projected. On both these planes, free and geometric forms dance lustily around an emphatic heart-shape defined by a heavy black outline. As is typical with Kandinsky's Compositions, this one, too, provides a catalogue of the artist's current imagery. Besides the familiar floating rectangles, squares, and several circles at both ends, formerly rare biomorphic references have joined the Bauhaus vocabulary without any sign of strain or strangeness.

Kandinsky's color in *Composition IX* is carefully adjusted to lend the middle plane an optically convex character, with the central red stripe pressing forward as paler hues gradually recede toward both margins. Hot and cold, free yet firm, decidedly "constructed" yet at the same time ornamental, *Composition IX* must be counted as one of the superlative achievements of the Paris period.

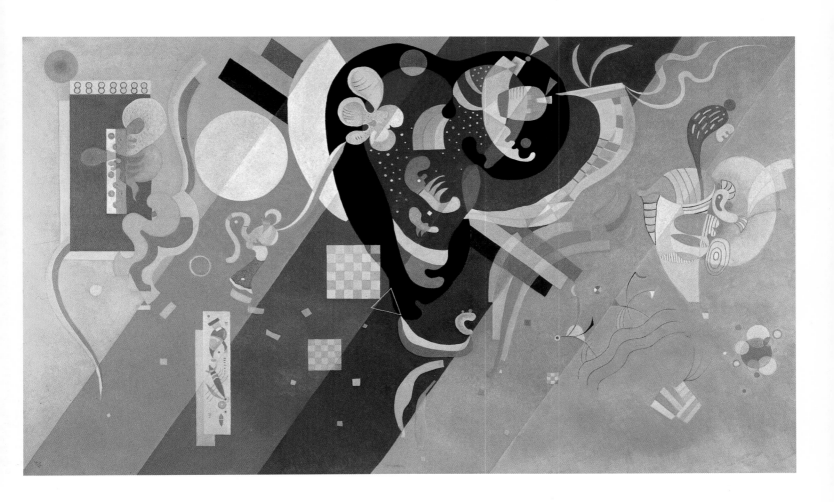

37. DOMINANT CURVE. 1936

Oil on canvas, 50⅞ × 76½" (130 × 195 cm)
Solomon R. Guggenheim Museum, New York

Only a few months after completing *Composition IX* (plate 36), Kandinsky embarked on another major undertaking, *Dominant Curve,* which in his own estimation attained the position of *chef d'oeuvre.*

Its lyrical color scheme notwithstanding, this large canvas evokes clashes between opposing forces. Tensions are felt in part on the surface, where an ultimately dominating question-mark-shaped curve resists an onslaught of black lines emanating from a large yellow circle at the upper left. A simultaneous pressure is exerted from the surface into depth, whence the aggression issues. More than in most of Kandinsky's paintings, we are aware of a sculptural third dimension, evoked by the powerful vertical shape near the center and even more so by a staircase image, in the right half, that atypically pierces the flatness of the surface. The staircase not only leads into depth but supports the vertical shape in its pointed dynamic.

These hectoring shapes stand somewhat in contrast to the pastel colors of floating circles and free-form elements. The incongruity, however, is diminished by soothing, playful surface accents, which provide a fluid rhythmic pattern throughout. A separate, emblematic form within a vertical rectangle at the upper left, as well as three black-rimmed, pulsating circles placed in a row at the opposing right margin, give additional iconographic impetus to one of Kandinsky's most powerful canvases.

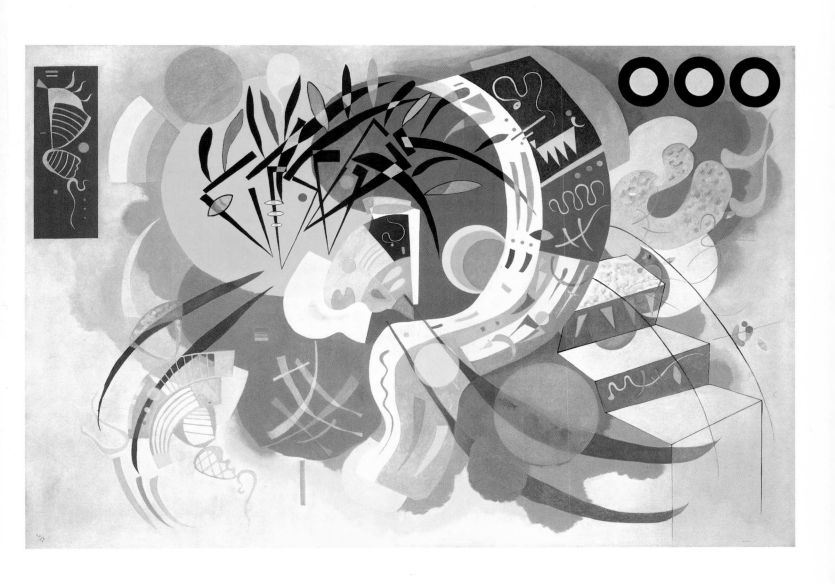

38. COMPOSITION X. 1939

Oil on canvas, 51⅛ × 76¾" (130 × 195 cm)
Kunstsammlung Nordrhein-Westfalen, Düsseldorf

Composition, in Kandinsky's personal terminology, referred to a major painting, carefully prepared and deliberately constructed, that exemplified his current creative concerns. These paintings have had diverse fates. Unfortunately, the first three works so designated were destroyed in World War II, a loss mitigated by the preservation of *Sketch for "Composition II"* (plate 8), which, apart from being one half of the lost work's size, remains a full-fledged substitute. It was purchased by the Solomon R. Guggenheim Foundation, thus joining *Composition VIII* (plate 30), which at an earlier date had been given to it by Mr. Guggenheim. *Composition IV* (plate 15) as well as the present work, *Composition X,* were purchased by the Kunstsammlung Nordrhein-Westfalen from Nina Kandinsky after the artist's death. *Composition V* (plate 16) is the only Composition remaining in private hands, as of this writing, while *Composition VI* and *Composition VII* (plates 20, 23) are the capital works that the artist was persuaded to leave in museum storage in Russia when he departed from the Soviet Union after World War I. *Composition IX* (plate 36) was bought by the French state from Kandinsky after he settled in Paris.

Composition X is the last of Kandinsky's ten grand symphonic creations. It differs from previous Compositions in its apparent separateness from the other paintings of its period. There are no related versions from either before or after its execution, no preliminary sketches or elaborations in any medium. Perhaps as a result, it gives the impression of greater spontaneity and abandon. Although the painting is meticulously structured, we seem to be viewing a nocturnal bacchanalian dance of abstract forms, a *pas de deux* of loose shapes and somber colors set on an entirely black background.

As is mostly the case in Kandinsky's Paris period, reminiscences of the objective world are paired with organic and geometric signs suggestive at times of universal or cosmic meaning. In the prominent, coloristically subdivided circle at the upper margin of the canvas, such sources tend to merge, while open-book forms, chessboards, and flamelike fangs carry more specific, earthly connotations. The prime tension in *Composition X,* however, arises between two large, anthropomorphic forms—one loosely held together, the other more compact—whose bases touch, their upper parts remaining in rhythmic imbalance as they incline away from each other. Although the two forms are placed in cosmic darkness, they are defined by a color scheme that allows a few yellow accents to gleam within the subdued tonalities. As a result, the work, despite its awesome symbolism, projects a sense of humorous mystery.

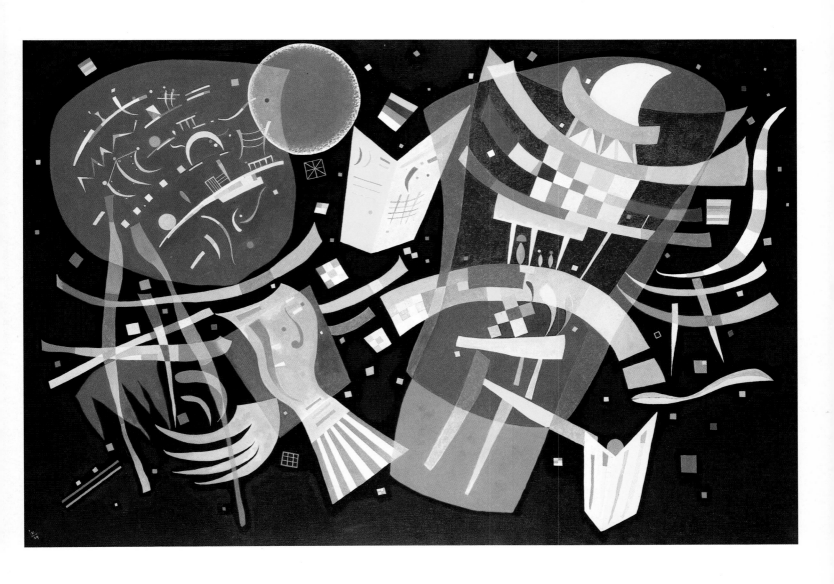

39. RECIPROCAL ACCORD. 1942

Oil and ripolin on canvas, 44⅞ × 57½" (114 × 146 cm)
Musée National d'Art Moderne, Centre Georges Pompidou, Paris.
Gift of Nina Kandinsky

A compositional structure in which prominent forms, approaching from both sides, bear in on a central vacuum is a recurring feature in Kandinsky's work. It can be noted as far back as *The Blue Mountain* of 1908–9 (plate 5), and later in *Development in Brown* (plate 35), but it reappears perhaps most clearly in *Reciprocal Accord,* considered Kandinsky's last major easel painting, which he completed at the age of seventy-five. (He painted only three further canvases after *Reciprocal Accord.*) Like *Composition X* (plate 38), this is an encounter between relatable yet distinct forms; from their abstract properties we derive human and situational analogies that are no less forceful for remaining implicit.

Kandinsky himself injected the notion of a "reciprocal accord" between forms through his title, thereby inviting anthropomorphic interpretations. In the composition, two wedge-shapes incline toward each other as their respective sharp lower points touch the bottom edge of the canvas. The prominent wedge-forms in both instances are reinforced, or perhaps burdened, by a collection of quasi-geometric and biomorphic planes that appear to participate in the action. Circular, rectangular, and organic shapes float between the two protagonists as well as behind them, as if they were the object of negotiations. A grave, ceremonious ritual is suggested by the nearly symmetrical form-personages as they leave their respective pastel backgrounds to enter a shared, off-white central environment.

The term "synthesis," with its varied and not always compatible connotations, has often been applied to Kandinsky's aims. The artist himself used such a concept to emphasize his belief in the essential interrelatedness of all the arts, and beyond these of all human endeavors. In one sense, the present work seeks a synthesis of its two principal graphic elements. Yet *Reciprocal Accord* could also be viewed as a work of synthesis in a broader sense, since it links in masterly fashion the free, biomorphically derived vocabulary of Kandinsky's Parisian phase with the geometric grammar developed at the Bauhaus. Finally, this painting demonstrates the artist's persistent concern with an objective world, which, although dissolved and sublimated into abstract configurations, continued to nourish the inner meanings, what he called the *Klang,* of his multileveled art.

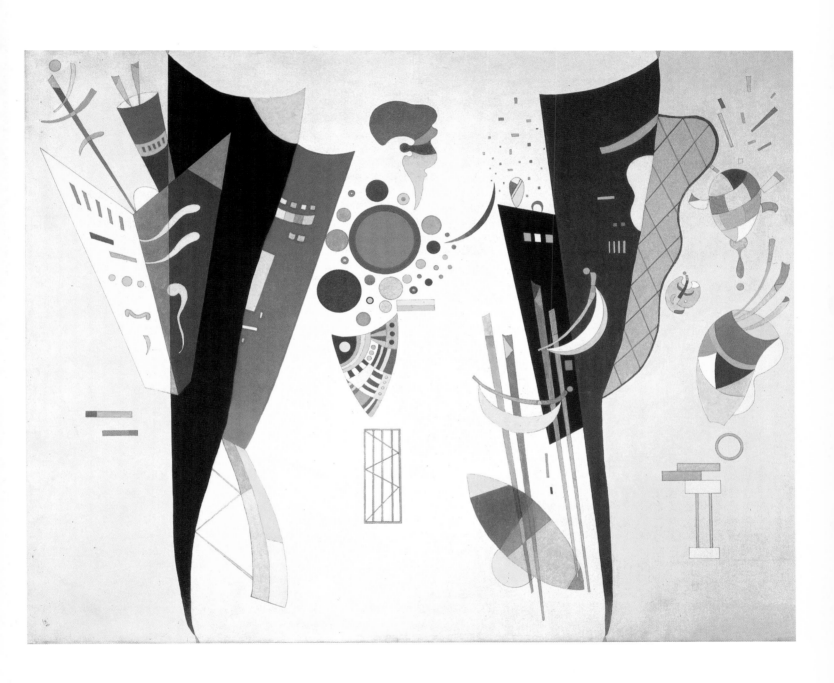

40. TEMPERED ELAN. 1944

Oil on cardboard, 16⅜ × 22⅞" (42 × 58 cm)
Musée d'Art Moderne, Centre Georges Pompidou, Paris.
Bequest of Nina Kandinsky

After *Reciprocal Accord* of 1942 (plate 39), Kandinsky painted only three canvases, none of which exceeds one meter in height or width. Canvas virtually disappeared in favor of cardboard or wood, and gouache or tempera was often combined with oil. The scarcity of materials during the German Occupation is usually cited as an explanation for this reduced physical scale. The smallish paintings of Kandinsky's old age are, however, possessed of a poignancy and an imaginative freedom that secure for them a special place in the artist's oeuvre.

As in so many of Kandinsky's paintings, and as made explicit by the alternate title for *Composition IX* (plate 36)—*The One and the Other*—the artist was fascinated by ideas of duality and by the contradictions inherent in a designation such as *Tempered Elan*. In purely formal terms, a duality is reflected in the marked division of the surface by a heavy, not to say aggressive, diagonal wave-form, which effectively separates two emblematic images from each other. Since *Tempered Elan* was painted early in 1944, the year of the artist's death, and since furthermore there are unmistakable references to an angelic form on one side and the familiar mounted rider on the other, the temptation to endow the work with transcendental significance is very great. It will, however, be resisted here since overinterpretations in the Kandinsky literature already hamper the ability to see this small work in all its formal purity and expressive directness. But, as with all works from the artist's hand, viewers are of course free to assign to his last completed painting a wide range of possible meanings.

Kandinsky's ever ambiguous position toward the ultimately irresolvable definition of reality—his oscillating moves between content and form, between the figurative and the abstract, and finally between the recognizable and the unfathomable—may have been what caused him to paint a work like *Tempered Elan* in his old age. He no longer felt bound by conventions or theories, even his own.